ART TECHNIQUES FROM PENCIL TO PAINT

LINE TO STROKE

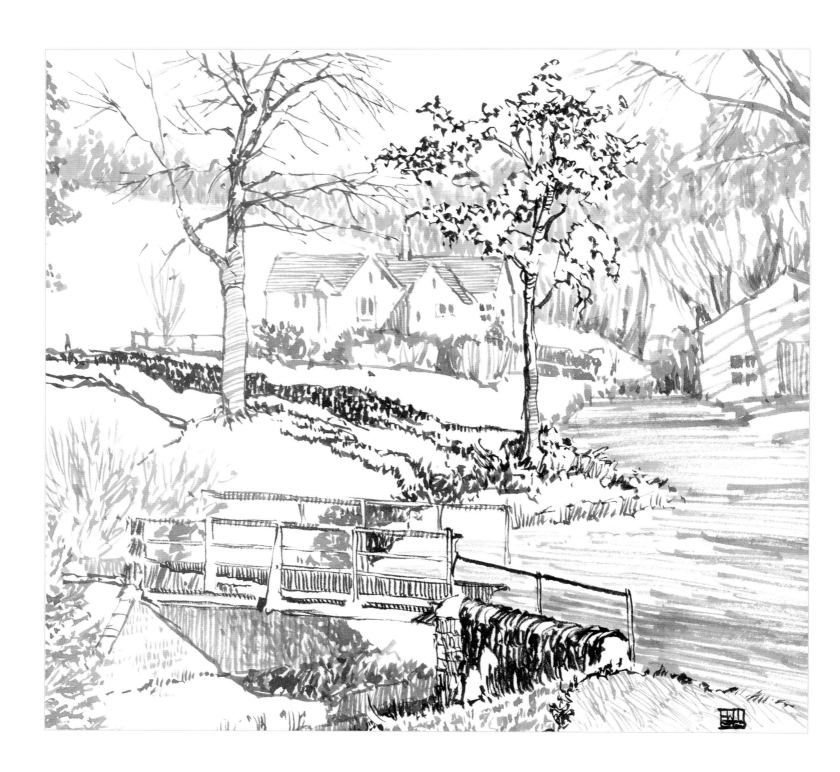

ART TECHNIQUES FROM PENCIL TO PAINT

LINE TO STROKE

PAUL TAGGART

Sterling Publishing Co., Inc.
New York

Concept, text, illustrations and photographs © Paul W. Taggart 2002

Paul Taggart has asserted his rights to be identified as the author and illustrator of this work

Series concept and structure by Eileen Tunnell

Design & Layout by Sunita Gahir, Big Metal Fish.com

© TAJ Books Ltd 2002

Library of Congress Cataloging-in-Publication Data Available

10 9 8 7 6 5 4 3 2 1

Published in 2003 by Sterling Publishing Co., Inc.

387 Park Avenue South

New York, NY 10016

First published in Great Britain in 2002 by TAJ Books Ltd.

27 Ferndown Gardens

Cobham, Surrey, KT11 2BH

©2002 by TAJ Books Ltd.

Distributed in Canada by Sterling Publishing

C/o Canadian Manda Group

One Atlantic Avenue, Suite 105

Toronto, Ontario, M6K 3E7, Canada

Printed and bound in China

Sterling ISBN 1-4027-0222-1

CONTENTS

Drawing can be fun. Sadly, however, most people don't believe this to be so, for a variety of reasons. For many the dislike of drawing started early. Perhaps first experiences made it seem boring, technical, or something that might expose the inadequacies of a beginner. If that was what happened to you, then you are not alone.

Often, the word alone can bring a look of horror to the eyes of many a group of would-be painters. "Can't I paint without having to draw first?" is a common plea from those having a go for the first time.

I wonder how many people have been discouraged from taking up painting because they have heard that opinion expressed all too often?

It suggests that technical ability in drawing is required before one is allowed to enjoy the riches of painting.

Cast your mind back to the art class in your school days. Were you one of those instructed to explore the subtleties of line and tone, equipped only with a pencil or stick of charcoal? So rooted in our subconscious is this notion that most of us, including myself, have at some time felt that a barrier exists between drawing and painting. I came to realize that this barrier should not exist. Drawing is a natural element within any painting, quite apart from encompassing a group of media in it's own right.

If you can hold a pencil or brush, you can draw.

The act of drawing is simply making marks in response to what we see with our eyes, or in our mind. It is multifaceted, ranging from a scribble to a complete work of art. Through it we communicate our experiences, either for referring back to in the future or to communicate with others. Furthermore, it is not simply restricted to the realm of pencil. Drawing can be accomplished in chalks, charcoal, pastels, ink, watercolor, oils, and so on. In fact, if what you are holding in your hand makes a mark, it can be used as a drawing tool.

Drawing is just as exciting as painting and certainly as rewarding.

When I set out to select a subject to paint, I always start with a drawing. I am not trying to create a finished piece, as that will be the function of my painting. However, making marks on a piece of paper inspires me and I then have something tangible with which to play around, and in which changes can be incorporated as I pick up more information from the subject being studied.

As you work from nature, your gaze becomes intense. You may have seen a tree in the garden or your close friend a thousand times before, but when you start to draw these subjects it is as if you

are seeing them for the first time. Often, when deep into a drawing, you will experience a unique closeness to the subject. You will examine and dissect with your eyes and as you do so the brain builds up a mental record and a deeper understanding of the subject. In this way your visual memory is expanded.

If someone were to ask me to draw a giraffe for example, although I feel that I know exactly what a giraffe looks like, my drawing would in fact be sorely lacking at the first attempt. If, on the other hand, I had drawn a giraffe in the past, my recreation would be so much more accurate, as I would be able to dip into my inner library of visual impressions.

This is precisely one of the frustrations that everyone faces on taking up painting. Do you feel that you have a strong mental image of the subject ready to be portrayed? However, on picking up the brush, the image seems to dissolve; and, on trying to depict it, it disintegrates into a sad, misshapen jumble. The natural reaction is to blame oneself for lack of ability. The truth, however, is simply that you weren't truly familiar with the structure and form of that subject. This is where drawing comes to the rescue.

I do not believe that the drawing which you complete to gather information is in of itself important. It is the look and learn process as you study the subject, which is. The looking must be intense, if you are to translate what you see into marks on paper.

What can also discourage potential artists is the mistaken belief that drawing can only be executed using a pencil. Are you one of those who has labored with a pencil to produce a drawing, finding it slow and unexciting in comparison to splashing around with paint? Some, of course, enjoy the measured build up of pencil lead on paper; many others discard it, and, more often than not, the consequence is that they also discard the whole range of other drawing possibilities along with it.

I believe that whatever the drawing medium, it should always be as exciting and unpredictable as painting.

If this were not so I would no longer be an artist. Stimulation must be a prerequisite to any technique. If the artist is not fully involved in and exhilarated by his/her work, how can he/she expect others to react to it in a positive way?

You can of course get started on painting without the need to be proficient in drawing.

However, if you approach drawing in the right way, it can not only be an enriching experience in it's own right, but will lead you naturally into the practice of handling a brush. There as so many avenues in drawing that have direct links to painting. Follow one and you are painting even before you know it.

The misunderstanding of this simple truth has put so many on the wrong track. From my own personal experience I remember starting with pencil drawing. I became proficient in the practice, but when I then wanted to paint I was reluctant to begin all over again and make all the mistakes that learning a new skill brings with it.

How much more easy to stay with the range of techniques I had already mastered. The barrier which I found so difficult to overcome should never have been there in the first place. I had not been shown and could not see that by using a pencil I had learned so much about structure, tone, balance, composition, etc.—all of which could be applied directly to the use of paint. The method of holding my pencil, its angle to the surface, the pressure applied all would help me to use a brush efficiently.

There really is no difference between drawing and painting. When you are painting you are still drawing.

The act of drawing is simply one of understanding the medium, looking carefully at your subject, and making marks in response to that stimulus. This can be done with a piece of twig, just as well as with the most expensive sable brush. What matters is the process that develops as the idea passes through the eye, the brain and down through the hand, onto the surface.

No matter what our level of skill, something

occurs here which makes the statement personal, unique, and enriching for ourselves and those who view it. It provides an insight into our personality and is thus a direct channel of communication between each other and a universal one at that. It is one that requires no language skills, is timeless, and cares little for age or social barriers.

Join me in exploring this exciting territory. We will start gently, with inexpensive materials, slowly building up confidence and skills. Some may decide to stay with simple materials, which can give many years of joy. It is my hope, however, that you will be caught up by the experience and go on to relish all the richness that drawing and painting has to offer.

A world of possibilities are open to you. Go on, pick up that pencil and start scribbling.

Pencils

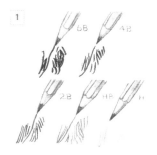

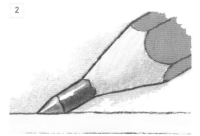

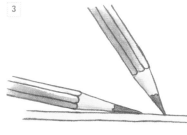

STANDARD PENCILS

1. Differing degrees of hardness allow fine line or dense soft coverage, depending on your requirements.

2. Sharpen pencil with a sharpener. Pare back wood with sharp craft knife to allow shoulder of pencil easy access to working surface.

3. Use point of pencil for detail and linework and the side for shading and faster coverage.

AUTOMATIC & CLUTCH PENCILS

4. Automatic Pencil 0.5mm leads and lead dispenser. Ideal for line and line shading.

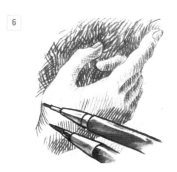

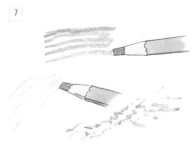

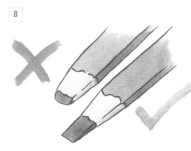

5. Clutch Pencil 2mm 2B lead ideal for descriptive line and shading. Sharpener at rear of pencil. Much more effective to buy a separate sharpener specifically designed for this pencil (available in metal or plastic).

6. Automatic and clutch pencils are perfect for the techniques of hatching and cross-hatching to produce a variety of tones and textures.

CHISEL SKETCHING PENCIL

7. The versatility of this pencil makes this an invaluable addition to your repertoire of techniques.

8. Never allow it to get blunt, or you won't be able to exploit its unique drawing potential.

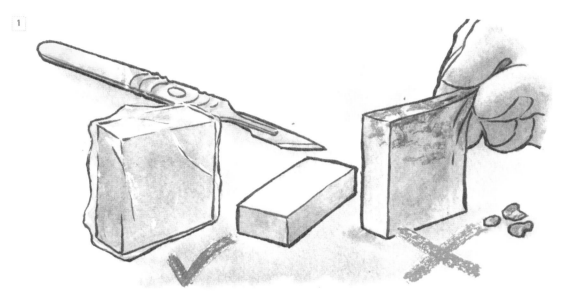

2&3. As with the brush, the eraser can be used to create line, lift-off an area completely or in part. It can be used with stencils in both the removal and application of graphite, going far beyond the mere task of erasing.

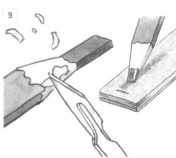

9. Gently whittle away the wood, avoiding the lead. Finish off by sharpening lead on a sanding block.

KNEADABLE PUTTY ERASER

This is one of the most versatile tools in an artist's kit. As well as erasing, it can be used for many of the tasks that are achieved when using a brush in painting. These erasers vary enormously in character, from one manufacturer to another, with some being extremely soft and malleable, while others are somewhat stiffer. Hold one in the palm of your non-painting hand as you work and the warmth will soften those that are a little hard.

1. While the eraser can be cut down, with the unused section being stored for future use, don't pull the soiled parts off and discard them. Even though the eraser will become discolored, it should be turned in on itself to expose a clean section and also retain its bulk. This prevents it from becoming smaller, resulting in more practical and longer use. Eventually, when it has become too dirty overall and there are no further clean parts to expose, discard it and replace with a new one.

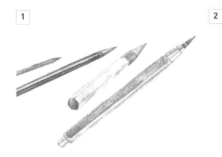

Graphite Pencils, Sticks & Holders

1. Graphite sticks are available in a variety of types, all of which are ideal for shading. Pure graphite lead, with no protective layer, intended to fit into a holder (*left*). Graphite lead enclosed in a plastic sheath to prevent the soiling of hands (*middle left*). Thicker sticks with a special finish to reduce soiling (*middle right*). Graphite stick holder that can also be used to take charcoal sticks (*right*).

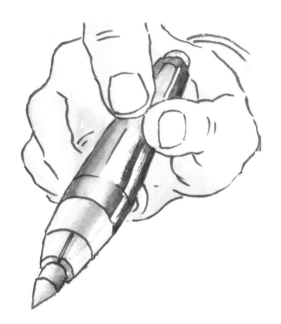

2. Based on the same principle as the clutch pencil, the metal end springs open to clutch hold of not only graphite leads, but can be used to hold leads, pastels, or charcoal of varying thicknesses.

3. Clutched in this holder the graphite stick can be used to within at least 12mm of its end without losing flexibility. Also gives greater control of such short lengths.

4. Larger unsealed sticks can also be wound in masking tape to provide a protective sheath. Unwind in sections as stick grows shorter.

Paper Wipers

5. Also known as stumps or stubs, these are used to blend, soften, and smear pencil, graphite, or pastel marks and can be made of compressed paper or of rolled paper. The compressed paper variety is much stronger and therefore more effective when working on textured papers, as you can apply more pressure and force the graphite into the surface.

Pens

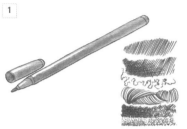

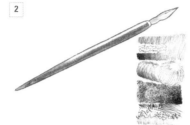

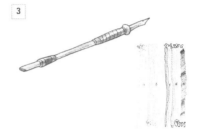

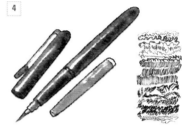

FELT TIP PENS

1. These most basic of pens are readily available and cheap. There are many colors around, either singly or in sets. They do, however, lose their points quite quickly and therefore it is best not to expect detailed control — they make ideal scribbling or sketching tools for anyone to try.

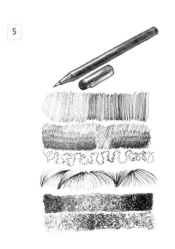

DIP PENS

2. A more robust and "scratchier" pen that is best used for swift, sharp hatching and cross-hatching. Use a drawing italic pen point to create alternative fat and thin lines.

FIBER TIP PENS

5. This pen has a sheath that protects and strengthens its point. Available in various thicknesses from 0.1mm to 0.9mm, it is excellent for producing constant lines of equal width.

Fine hatching and cross-hatching techniques are easily produced. Line thickness is difficult, though not impossible, to vary by altering the pressure. Textures which necessitate swift equal line thickness are the answer.

REED PENS

3. These handmade pens are beautiful objects in their own right and follow a tradition that stretches back to distant times. Being made of reed, they are light to handle. A well-made pen yields incredibly fluid ink flow. There are many shapes to choose from and each pen point can be used with great effect to produce a variety of marks.

INKS

6. Ink is a dye that stains paper, rather than a pigment that lies on top. This causes ink to fix or dry more rapidly than paint such as watercolor. Luminous, transparent, and ideal for fluid lines and strokes, inks yield a quite different quality.

BRUSH PENS

4. Based on the principle of a fountain cartridge pen, the pen point is replaced with a nylon brush head. The resultant flexibility of the brush head allows for fluid brush strokes and the unique properties of being able to produce sketches or scribbly drawings. This is one of the most versatile tools around, and one that I use extensively, both in finished works and for sketching out and about.

Drawing Tools

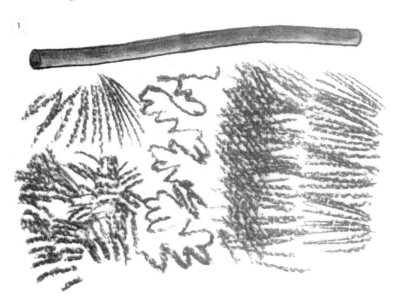

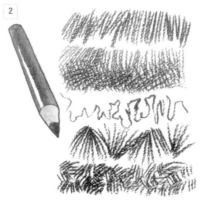

CHARCOAL PENCILS

2. These are more sophisticated, as the charcoal is ground down and reconstituted in pencil form. In reforming, the softness or "degree" of softness can be controlled.

The sharpened point and regularity of the charcoal in pencil form allows for great control in use. These can be used to great effect in selectively reinforcing areas of softer drawings completed with the natural charcoal sticks.

CHARCOAL STICKS

1. Charcoal is formed of lengths of burnt wood, usually willow. This seemingly crude drawing tool has provided generations of artist's over the centuries with a medium that can be sensitively used or put to dramatic effect.

The results are very soft, and, when drawn over a surface such as the rough watercolor paper used for this example, produces an interesting textured effect. Once applied, it can be easily smudged and smeared with a finger or paper wiper, for atmospheric results. Sharp, detailed linework is difficult to maintain and the charcoal stick itself can prove irregular, as the wood grain varies. Charcoal sticks are available in an incredible variety of thicknesses, from fine sticks to large lumps, used for ambitious and dramatic works.

CHALKS

3. Colored chalk is cheap and provides a marvellous starting point. It is, however, generally weak in pigment, so a bold, simple approach is required and limited mixing can be achieved. This medium works best therefore on a colored surface.

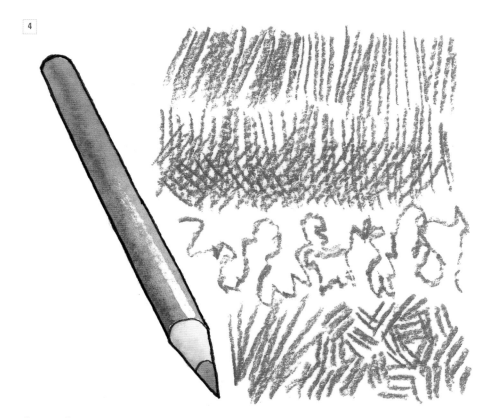

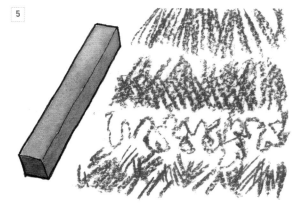

SKETCHING PASTELS

5. Nearly all pastels are sold as "soft pastels," but these are the slightly harder variety. They can be square or round in cross-section and tend to be more gently pigmented than the Artist's Quality soft pastels. Being cheaper, they tend to be sold as sets.

PASTEL PENCILS

4. Colored pencils with a softer pencil lead these are often available in color matching pastel ranges. They can therefore provide the detail that the heavier pastels find difficult.

The strokes may look a little crude on a heavily textured watercolor paper, such as the example shown here, but they improve on the fine tooth of a pastel paper. Soft linework and strokes blend well with their pastel companions.

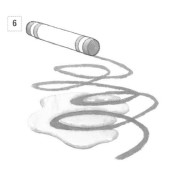

WAX CRAYONS

6. Once merely a child's drawing crayon, they have become more sophisticated and thus attractive to artists. Being resistant to watercolor, these crayons offer interesting effects when used in conjunction with it.

COLORED PENCILS

These possess all the qualities of the traditional pencil and can be used in exactly the same way. Unlike Watercolor Pencils, these do not dissolve in water, but they can be dissolved using a thinner such as Artists' Distilled Turpentine or White Spirit. They are a good way in which to become familiar with working in color, and the Artists' Quality are usually the most lightfast.

Colored pencils can be mixed visually on the surface by layering strokes of color over each other or lines next to one another.

As they can be bought individually, you may prefer to put together your own set of colors. But do store them in a flat tin to protect them.

The strokes can be finer on a specialist pastel paper, although there is something to be said for the bold textured strokes created on watercolor paper, as can be seen in this example.

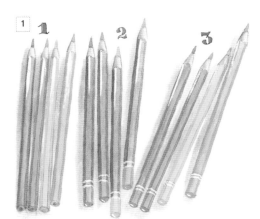

WATERCOLOR PENCILS

These differ from the ordinary colored pencils in that the dense pigment contained in them is held together by a gum that dissolves in water — the same principle as watercolor paint. As the gum dissolves in water, so do the pencil strokes. This technique can be used to soften the strokes or dissolve them altogether into a wash.

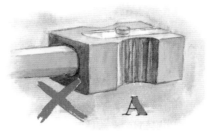

1. There are at least three qualities of pencil available. [1.1] A children's range that are cheap and cheerful and provide an excellent choice for introducing young artists to working with color and a brush. [1.2] The student's quality, which is better — but still relatively economical to buy — and ideal for those wishing to start without committing themselves to spending more on the best Artists' Quality. Both of these cheaper versions are usually only available in predetermined sets. [1.3] The ultimate quality and more expensive are more powerful due to the simple fact that the leads are more densely packed with pigment. These are offered as individual colors, allowing artists to build up their collection as they go. Also, in some cases there are eighty or more colors in the full range. Some manufacturers also offer two lead thicknesses. [4]

2. It is extremely wasteful of valuable pigment to sharpen a watercolor pencil in the traditional manner [2.A]. Better by far to pare away the wood using a craft knife, using a series of gentle cuts parallel to the lead[2.B]. Do this over something in which you can collect discarded crumbs of lead. These particles can be dropped into water on the surface of your work and used to create washes, splatter effects, and so on.

3. Once the applied strokes of watercolor pencil are wetted, the gum dissolves, which — when dry — fixes the pigment more firmly to the surface. Use the shoulder of a round brush or the flat edge of a flat brush to gently dissolve and flow the color. Move swiftly, using little pressure so as not to totally erase the linear quality of the pencil work.

Watercolors

PAINTS

Watercolor paints are made of powdered pigment that is bound together with "glue" called Gum Arabic, which dissolves in water. The more water that is added, the thinner the color becomes. Tubes of watercolor paint are best when large quantities of wash are required. Being semi liquid in the tube, they dissolve quickly and evenly.

This basic "palette" of six tubes will provide mixes of color for most of your painting needs, as shown in the section on Color Mixing - Red-purple (i.e. Crimson Red), Red-orange (i.e. Cadmium Red), Blue-purple (i.e. Ultramarine), Blue-green (i.e. Prussian Blue), Yellow-green (i.e. Lemon Yellow), and Yellow-orange (i.e. Cadmium Yellow).

Half pans are useful for spot coloring, or mixing small quantities of washes.

Cheaper quality paints work out more expensive in the long run, for they contain less pigment and you need more paint and achieve only dull mixes. Always better to go for a good quality Students' paint or better still, Artists' quality paint. The quality of students' paint varies so much across the brands that it is best to experiment first with one or two colors.

BRUSHES

2. (From left to right) Hake brush: very soft and made from goat's hair is ideal for washes and wetting over already laid areas of paint. Round brush: these come in various types, but it is best to work with a nylon/sable mix (A No. 10 is all you need). Flat nylon brush: used for painting and more importantly lift-off. Nylon rigger: ideal for linework and fine areas of hatching and cross-hatching.

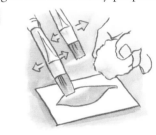

5. Paint can also exploit the technique of hatching and cross-hatching, using a special Rigger brush.

3. Use the point of the brush for detail and linework, and the side of the brush for shading and faster coverage. One good size brush applied at different angles can serve many purposes.

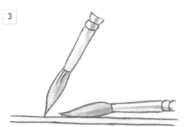

4. Highlights and masked areas can be removed using a damp flat brush and a piece of absorbent paper or tissue. This technique is known as lift-off.

6. For the techniques featured in this book, all you need are two palettes. A ceramic or plastic oblong palette with deep wells is essential for the diluted color mixes. The smaller round palette is often referred to as a tinting saucer and is needed for holding small quantities of ink. NOTE: Ink stains plastic but not ceramic surfaces.

Oils

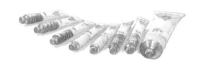
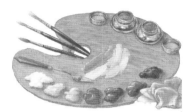

PAINTS

1. There is a staggering range of oil paints available, and, as with watercolor paints, they come in Students' quality or Artists' quality. I would suggest Students' quality to begin with, until you know that oil painting is what you want to pursue. Again, a limited palette will suffice to begin with, but one extra color is required, Titanium white for use on its own and to add to the other colors.

BRUSHES, PALETTE, THINNERS

2. Round bristle brushes are the most versatile. Two would be a good starting point, one several sizes larger than the other. Always go for something bigger than what you feel you will actually need. One nylon round brush makes up the starter set. Oil painting brushes have longer handles, so you can work further from the surface, and bristle hair which not only picks up the heavy paint but leaves a unique fingerprint texture of the brush stroke.

The palette should be made of a material that doesn't absorb the paints and is non-metallic, as an unfavorable chemical reaction can take place between oil paints and metal surfaces. Lay out your colors in the order of the color circle, around the perimeter, or along one edge. The center of the palette is left free on which to mix your paints.

Thinners (in dippers clipped to palette) are used to thin paint. Turpentine substitute or white spirit, used for cleaning brushes, leaves a residue of oil behind on drying. Whereas this does not matter when cleaning, you do not want such impurities in your paint, so the purer Artists' Distilled Turpentine is used for mixing. Linseed oil is also used for thinning, but takes longer to dry.

3. Oil paint is composed of two main elements, dry pigment or powdered color and a glue (medium) that fixes it to the surface. Traditionally, this is linseed oil.

In the tube, the mix of ground pigment and medium is balanced to produce a thick, easily textured paint.

This can be adjusted by adding thinner or more medium (linseed oil)

Acrylics

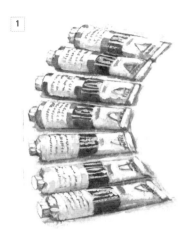

PAINTS

1. Acrylic paints have a light, creamy consistency, as a result of the medium (glue) it contains, which is white while wet. As it dries, however, it becomes transparent, changing the value of the paint. It is almost as if you are looking at a tint of the color, which is going to become stronger and darker as it dries. Acrylic will not mix with oils, but it will with watercolor or any other water-based medium. Acrylics dry very quickly and can be used either thin, let down with acrylic mediums, or thickened with gels.

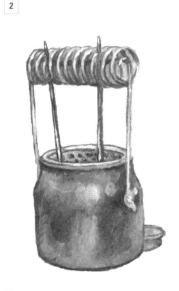

BRUSHES

2. The quick drying action of acrylics means that you have to be especially vigilant in the care of the brushes you use. Don't leave them lying around, even for a moment, as they will be rock hard before you know it. They can be kept wet during painting by immersing their heads in water, in a specially designed brush washer as shown here.

PALETTES

3. A stay-wet palette is essential to keep the paints moist during painting.

To make your own, get a couple of flat, shallow plastic trays with a rim on each. Cut two pieces of absorbent blotting paper to size and line the base of one tray. Cut two pieces of grease-proof paper to the same size and lay them on top of blotting paper as a membrane.

Pour water all over to soak right down leave to soak in, and then pour off excess water. Then gently blot surface with absorbent tissue.

Squeeze paint around the perimeter onto top membrane of paper and use middle for mixing. At end of painting session, fit second tray over first as lid and secure with tape or a rubber band. This will keep your paint for short periods. When paint can no longer be manipulated, simply lift off top sheet, discard, and replace with another. At all times keep every layer wet.

Gouache

1. An opaque watercolor paint, gouache enables the artist to overpaint layers and also to paint onto a colored surface. Bleed through from underlying colors can occur if overwetting or overworking occurs.

Drawing and Painting Papers

CLEANING AND LIFT-OFF

1. Absorbent paper towels are essential in your painting kit for cleaning brushes and lifting-off paint.

Craft tissue paper is not absorbent enough for watercolor or inks and should be kept for tonking (the technique where heavy color is lifted from surfaces without absorption).

CARTRIDGE PAPER

1. While the thicker versions are suitable for drawing, this paper does not contain enough size to provide an adequate surface on which to paint.

WATERCOLOR PAPER

2. This is one of the most important, yet underestimated, tools in the painter's kit. Having the right paper for your needs can make a huge difference to the finish of your painting. Try many to find what is right for you.

HANDMADE PAPERS

3. A plethora of amazing papers exists these days. Some are more suitable than others on which to draw or paint. Try them out for yourself.

PASTEL PAPERS

4. Again, a wide range exists and a variety of colors. It is important, however, that the surface on which you work has a tooth to hold the dry pastel powder in place.

Basic Color Circle

Almost every artist resists learning about color mixing in the early stages of their development. The basics, however, are simple, and once mastered will open up a world of difference to your painting. It is such a pleasure to be in charge of your color mixes. Not only can you match a color, you can also control the balance of hues and values across the whole composition. Suddenly, colors work for you and your paintings begin to sparkle. I advise painters to work using a basic palette of six colors, from which most colors can be mixed.

Three primary colors = red, yellow, blue. Primaries cannot be achieved by mixing. Only available directly from paint box.

Primary colors mixed together to make secondary colors.
Red + yellow = orange.
Red + blue = purple.
Blue + yellow = green.

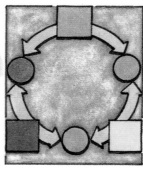

Three primaries = basic constituents of color circle and painters palette.

Pure primaries do not exist. Mixes can be unexpectedly dull. (E.g. Cadmium Red and Prussian Blue should give purple, but actually produce a muddy gray color.)

Because all primaries are biased toward the secondary, they mix best. Compatible primaries used to make bright secondaries.

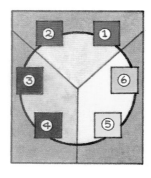

So basic color palette now extended to include two of each primary.
[1] Red-orange
[2] Red-purple
[3] Blue-purple
[4] Blue-green
[5] Yellow-green
[6] Yellow-orange

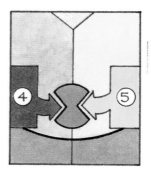

Close primaries mix to create bright secondary.
1+6 = orange
5+4 = green
3+2 = purple

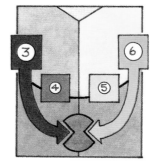

Distant primaries mix to produce dull secondaries.
3+6 = dull green.
5+2 = dull orange.
4+1 = dull red.

MIX CLOSE PRIMARIES
MIX DISTANT PRIMARIES
Complementary colors give tremendous contrast when placed next to each other, but mixed complementaries produce very dark, dull colors.

TERMS ESSENTIAL TO UNDERSTANDING COLOR MIXING
HUES
Bright primary and secondary colors are known as hues.
VALUE
Some hues are very light, while others are dark = different values.
INTENSITY
Dull colors have a lower intensity than the bright ones.
TONE
The degree of lightness or darkness of a neutral gray.

Color circle shows bright green, orange, and purple in place. Complementary color of each color on color circle sits opposite.

Tertiary colors can also be complementary to its opposite on color circle.

When complementary colors are mixed, it amounts to all primaries being mixed...

...and resultant mix absorbs all light falling on it, giving black (or dull gray).

Before black is reached, colors progress through range of subtle changes. Try other complementary mixes to find position of differing browns and grays.

In early stages of learning to paint, draw out color circle to aid you with color mixing.

To change a color's hue, add another color near to it on the color circle. Add yellow to red and change its hue to orange.

To change its tone or value, add water or more of the same pigment to the mix....

...or its complementary.

If you add water as well as complementary to mix, the color will not become darker, only duller = change of intensity.

Adding white to a color produces a tint. Adding black produces a shade.

Tinting strength is the staining power of a color. (E.g. Equal amounts of Prussian blue and yellow mixed will not produce green. It will remain blue as Prussian blue has a powerful staining property.)

Mixing on the Surface

This drawing has been developed using only six colors from a set of colored pencils. The weight and density of strokes are carefully balanced to give the drawing the appearance of having been produced from more than six colors.

Colors are kept pure and clean, and it is exciting to the eye to note that each can be identified from its fellow colors.

1. PETALS

Pink and dark red are the predominant colors. The pink gives solidity, while the dark red accents for petal edges. A gentle blue is laid sparingly on some petals to suggest shadow.

2. LEAVES

Amazingly, there are only two colors at work here, suggesting both light and shade. It really does matter which color is laid first, for the final color is always predominant in the resultant mix.

3. STEM

The blue and yellow are first mixed to create a cool green, which is then accented with the dark red. The latter, an opposite to green, creates both contrast and a dark accent, against which the green appears brighter.

4. FLOWER INTERIOR

The stamens are a soft yellow, moving to a green drawn into the petals. Warm brown, introduced to accentuate detail, is dull against the cool green, but rich against the warm yellow.

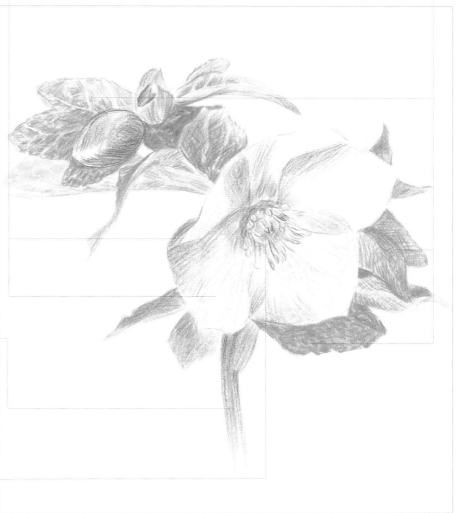

Mixing on the Palette

The great advantage of palette mixing is that a far smaller range of colors is required. Color can still be mixed on the surface, but you will already have a close match before applying. Every painter has his/her own preference as to what the basic color palette should be and a huge choice is available from the various manufacturers. Start simple, with as few colors as possible and you will soon learn all that is possible by mixing your colors. The value (light/dark) of a color is of greater importance than its hue (color). I find that by squinting my eyes I see the value of a color more easily.

All the colors in this study are dull. Analyze each carefully and identify to which hue they seem closest; then try mixing each by using complementaries to dull them down. It is only by trying these mixes out for yourself that your confidence in color mixing will grow. This particular exercise will also prove to you that dull mixes are every bit as important as bright colors.

1. This one is difficult, but the only color it resembles is purple. Mix it from a Red-purple [Rp](Crimson Red) and a Blue-green [Bg] (Prussian Blue), allowing for the individual strengths of each color. Dull it down with the complementary to purple, a cool yellow, Yellow-green [Yg] (Lemon Yellow).

2. Here we have a dull green. Mix it from a Blue-green [Bg] (Prussian Blue) and a Yellow-green [Yg] (Lemon Yellow) and dull it down with the opposite of green, a warm red, Red-orange [Ro] (Cadmium Red).

3. A brown is always a dull orange. The orange is mixed form Red-orange [Ro] (Cadmium Red) and Yellow-orange [Yo] (Cadmium Yellow); dulled down with the opposite of orange, a warm blue, Blue-purple [Bp] (Ultramarine).

4. This blue-gray is interesting in that it is mixed with only two colors. Red-orange [Ro] (Cadmium Red) and Blue-green [Bg] (Prussian Blue). Being nearly opposites on the color circle, they dull each other down and eventually create a good gray.

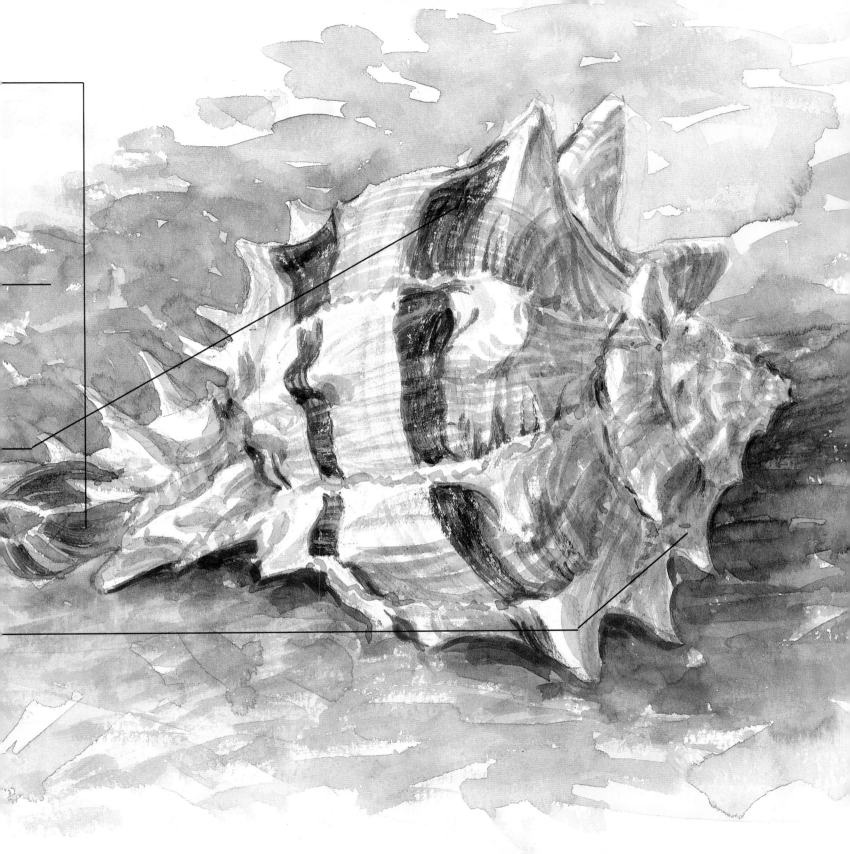

Blue Ball Point Pen
on Writing Paper

Introduction

So many people I meet tell me that they can't paint or draw. "I haven't got an artistic bone in my body!" they say. Yet when I ask if they have ever scribbled on a piece of paper they tell me they have. Of course they have, so has everyone at some time, on all types of surfaces. If drawing is so alien to us, why is that our minds turn to it as soon as we are relaxed?

What pleasure are we getting and what need are we fulfilling in producing a scribble? What is even more interesting is the fact that they are often very good! More often than not these scribbles are dismissed and thrown away. Occasionally we are pleased with them and stored them away as a keepsake.

Scribbles are marvellous, for they are drawings produced when the conscious mind can't get in the way of simply making marks. We don't feel we have to prove anything in them. What makes scribbling so irresistible is the lack of rules governing its execution.

From the earliest moments in human history, there has been the need to create marks. These have been done on cave walls, tools, clothing, homesteads, all type of objects, until the work was produced specifically for displaying as artistic objects in their own right. Are we marking our presence in the passage of time, or are we simply decorating our

world? The reasons are numerous, but what is most important is the fact that we all feel the instinctive need to create, and we all have it in us to do so.

WHAT IS SCRIBBLING?
There are no rules to a scribble. No scribble is incorrect. When you make the lines, they can represent edges, contours, shadows, volume, and texture — but you don't think about which is which, you simply do. To get you used to picking up different drawing tools with which to scribble, the following pages suggest simple exercises using items that are likely to be found in anyone's home. Their different characteristics will also show how materials are to be exploited to get the most out of them and this you can only do by using them time and time again.

You should be relaxed to scribble, so sit down with a cup or glass of something, let your shoulders slump, and think *"I'm going to enjoy this."*

MATERIALS
HB Pencil • 5B Pencil • Cartridge Paper • Scrap Paper
Colored Felt Tip Pens • Standard School Colored Chalk
Wax Crayons (*either children's or Artist's*)
Watercolor Paints
Watercolor Brush
Pen Knife or Craft Knife

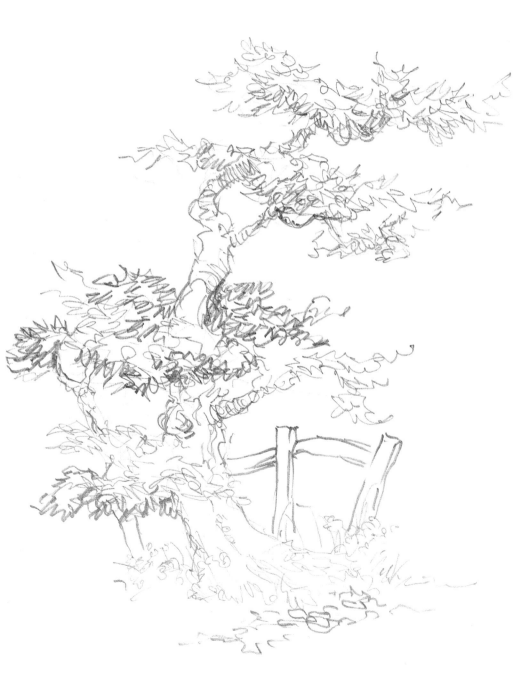

Pencil

Everyone has a pencil lying around somewhere in the house. Usually it is the average HB writing pencil.

HB PENCIL

This first exercise shows a scribble produced with just such an HB pencil. I chose the subject of trees because they are the most frequently requested subject for demonstrations and the most commonly started on by those new to painting. Choose something that feels right for you — a cup and saucer, a teapot, a pot plant, the cat — as long as it isn't something that requires any effort on your part and gets you going. The same pencil produces differing strengths of line depending on the different pressure you apply. As it becomes blunt, these darker marks automatically begin to suggest shadow or points of sharper focus. Variety of scribble is what excites the eye. Use your imagination to achieve as many differing marks as you can.

Don't use sharpener. Pare away wooden shaft from blunt lead with sharp blade.

Then lead sharpened with blade [top] or special lead sharpener [bottom].

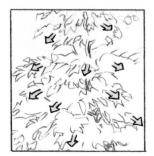

Look at direction of rythms of growth in lie of leaf textures

5B PENCIL

For the second exercise, a much softer 5B pencil is used and you will feel how much more responsive the pencil is to pressure. The darker accents are now more powerful. Begin by gently sketching in two triangular shapes to "contain" the two trees, so that as you position the leaves within you can be much more irregular with their placement.

Note the spaces between the leaf marks and how irregular these are. Once the leaves are completed, draw the branches and trunk between them. You will find that as you add the wood, the tree will suddenly begin to look more three-dimensional.

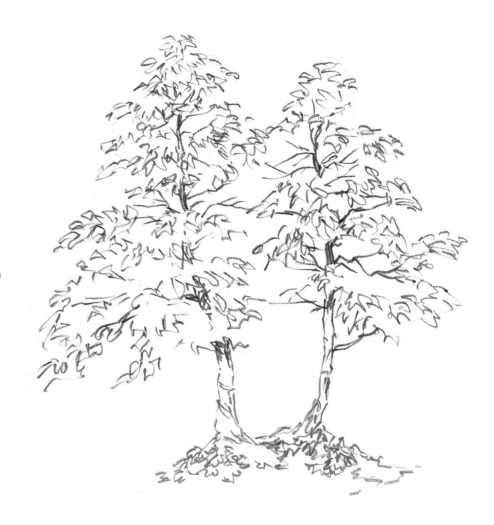

Felt Tip Pens

Available everywhere these days and at very reasonable prices, felt tip pens come in a rainbow of colors and are an excellent way to begin using colored lines. Changing the pressure or angle of the point on the surface of the paper changes the nature of the mark. Try working on different types of paper. Smooth cartridge paper will allow excellent control, but try more absorbent paper such as brown wrapping paper, sugar paper, or even the back of old envelopes. Differing textured papers made for watercolor affect the line in lots of interesting ways. These examples were completed on a thick cartridge paper.

FELT TIP PEN
To draw the pink tree simply start in the middle of your paper. Allowing the shapes to "grow," just as you might if you were doodling while on the telephone.

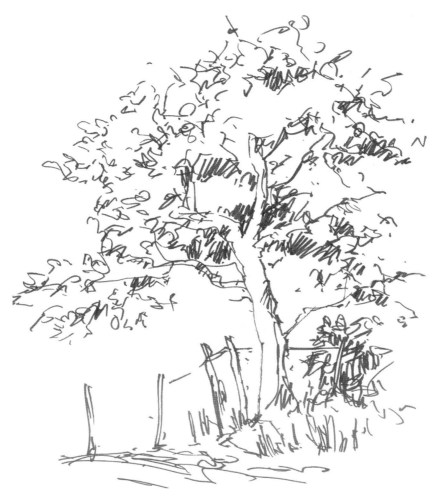

Hold near end to produce loose, gentle line. Loosen wrist and relax.

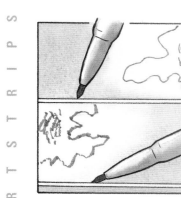

Vary angle of application to produce different line thickness and quality.

Hold pen near tip to produce controlled, strong line.

A R T S T R I P S

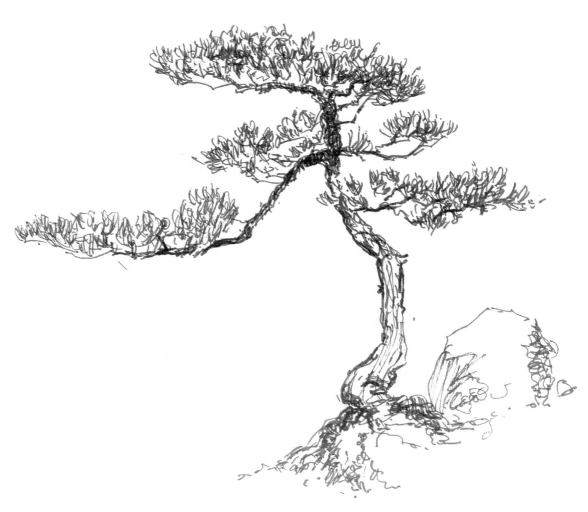

FELT TIP PEN

The green tree is more structured, for which I used a book on Bonsai trees as my reference. Similarly, you will find something in a book or magazine, or even a calendar or postcard. This is a two-stage scribble, with an initial gentle sketching in of the main shapes of the leaf masses with the pen.

A slightly tighter drawing will result as you respond to the textures and edges that you observe as the drawing develops. Soon you will begin to note patterns and rhythms that flow into the drawing.

Chalks

You can gain initial experience of soft dry drawing media (pastels) by starting with cheap school chalk. The colors are not of course as rich as pastels, for chalk contains much less pigment, nor are they available in such an extensive range of colors. Nevertheless, being cheap and easily available they give immediate access to a dry soft medium with which you can experiment. The examples here were again drawn onto smooth cartridge paper. However, do experiment with other surfaces. Dry media such as chalk and pastel really do benefit from being worked onto a surface with texture. This "tooth" holds the loose colored particles more effectively than a smooth one. It also creates unique qualities of mark that can be exploited in the drawing.

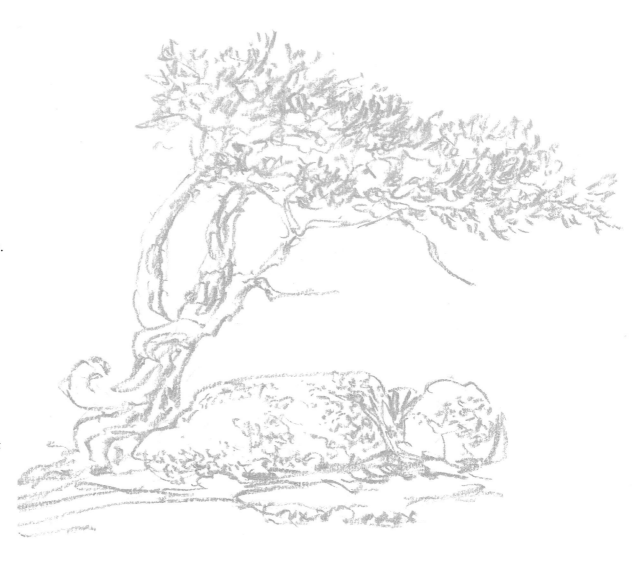

ORDINARY SCHOOL CHALK

Work from the top of the drawing so that your hand does not smear the chalk that is already applied. Alternatively, work upright so that your hand is not tempted to rest on the paper surface. Every so often, tap the paper so that chalk not fixed to the surface of the paper falls away. This keeps the drawing clean and helps prevent smearing.

ORDINARY SCHOOL CHALK

You will find that the application of line is fast and fluid. Don't work too small, or you won't be able to respond to the immediacy of the line.

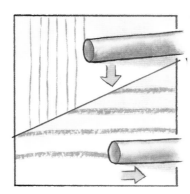

Draw with rim of unsharpened chalk to produce fine line [top]. Pull edge along to produce softer, thicker line [bottom].

To suggest leaves, "rock and roll" unsharpened chalk/pastel to create irregular line textures.

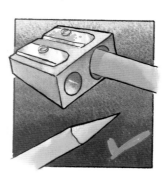

Use large pencil sharpener to point chalk stick for fine linework.

NOTE
Chalk/pastel drawings need fixing once complete. This can be done with a fixative designed specifically for the job, or as a cheap alternative for simple exercises such as these with hair spray.

Wax Crayons

These are available as cheap children's crayons or as a finer artists' crayon, either of which give a soft responsive line when used on white cartridge and resemble pastel when used in only one color. The mark is much more permanent however, and you must be very decisive, yet loose, since erasures are difficult. The crayon can be sharpened in a large pencil sharpener and /or you can rotate the crayon during use to keep the point sharp.

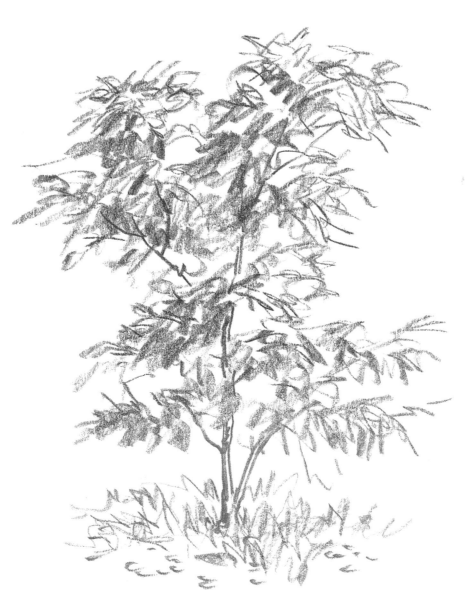

Scratching: use small crayon piece side-on to gently create oval area. Strengthen center.

Cover with several layers of white crayon, slowly increasing pressure.

Resists: White crayon on paper can be difficult to see. Occasionally hold against light to check.

SCRATCHING THROUGH LAYERS

Due to the waxy nature of the material, layers can be overlaid successfully. In this example, a gray solid color was laid in an oval shape. Then heavily covered with white and built up with pressure into a "frosted" finish. The scribble is scratched through the white to reveal the gray beneath by using a sharp pen knife or craft knife. Try this technique with different color combinations and different tools to scratch through the "drawing."

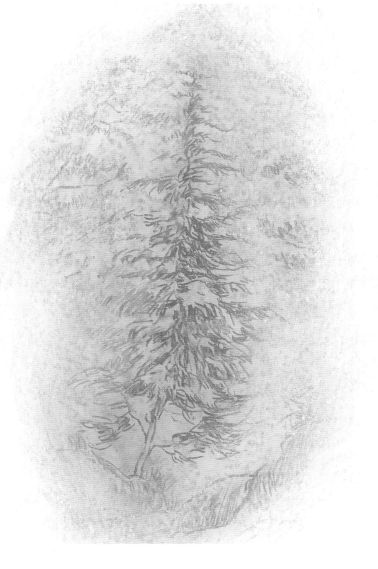

RESISTS OF WATERCOLOR WASHES

Wax also resists water-based paints. This example was produced using a white wax crayon to produce the scribble over which was loosely brushed a watercolor wash of yellow/green. This showed up the textured line over which, once the wash was dry, a second layer of white crayon was applied. The application of a second wash of blue (top) and purple (base) resulted in the second white looking yellow/green. This is due to the first wash showing through the second layer of wax crayon. Play around with this technique, building up layers of colored line and overpainting with watercolor washes.

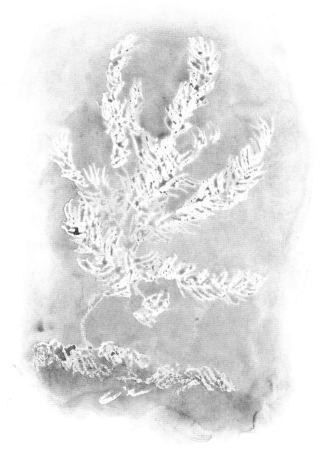

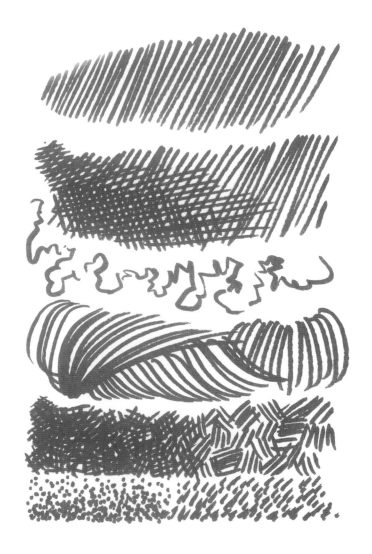

Felt Tip Pens

The marks from a felt tip pen are very strong, so you must respond accordingly and be bold in their application. They do respond to variations of pressure but the ink is a powerful stain that rapidly seeps into the paper's surface. Cross-hatching soon becomes dense, but dotting and dashing to create textures is very fast and rewarding. You can compensate for the lack of detail by working on a large scale. A set of colored felt tip pens makes for an ideal set of materials to take out and about or vacation.

A large scribbly sketch such as this should be enormous fun to complete. Find a large sheet of scrap paper. In this instance I used the reverse side of one of the rejected proofs from one of my limited edition prints, which gave me a lovely smooth surface on which to work! Simply start in the middle, or if you prefer, sketch in the main masses using a minimum of pencil guidelines. The benefit of the ease of ink flow, coupled with working on a large scale enables you to create rhythms and to work at speed. Don't worry about detail or any bleeding of the ink on the surface. Work all through the sketch in one color, using it in as many places and in as many different ways as you can manage before applying a further colors. This will encourage you to work with the minimum of color, preventing the sketch from becoming too garish.

MATERIALS

Colored Felt Tip Pens

Scrap Paper

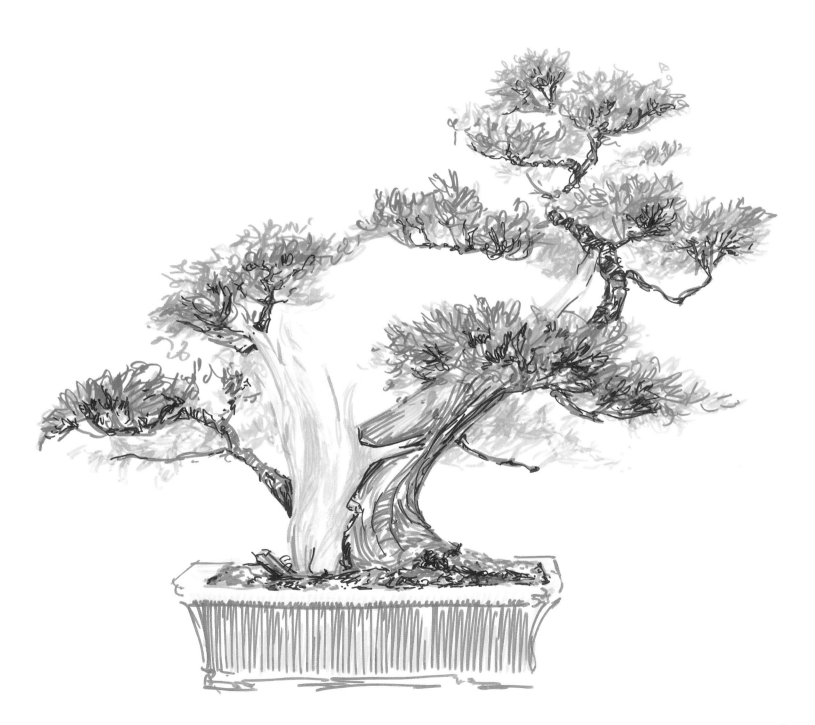

A colored pencil "sketch" emerges from a "scribble."

Introduction

The difference between a scribbling line and a sketching line is a very subtle one. In the last section we started playing with pencils, felt tips, chalks, wax crayons, and even a ball point pen, experimenting with the quality of mark each one of these different drawing tools provide. Whether drawing something from the imagination or looking to a photograph for inspiration, the exercises were based on exploring the line rather than the subject. This is a wonderful starting point, learning what each medium is capable of before attempting to match it to any particular subject matter.

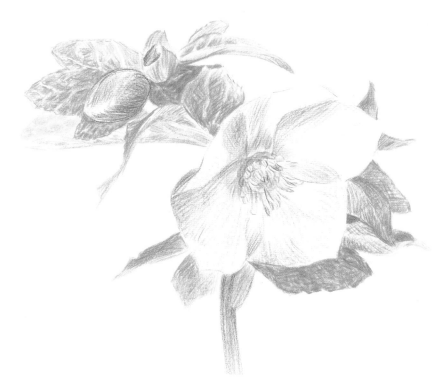

Now we move on to the art of "looking." As you begin to look more carefully at objects, you begin to search out and discover their true nature. Slowly you begin to look "beneath" their surfaces, to the simple beauty of their underlying structure.

Sketching is exciting because you are still not so serious that you are going to call your work a drawing. At the same time, however, you are now using your drawing tools as a means to look closely at something with more intensity than you have ever done before.

We have all heard someone say that they are good at drawing one particular subject. It may be trees, faces, horses, figures, etc. For some reason we feel that it would be natural to have an ability to draw one

particular thing, often in one particular way. If you were to delve into the reasons behind someone's "unique" ability, you will usually find that for one reason or another, in their past, they have been enthused and encouraged to draw that subject. Usually, a confidence-boosting compliment from someone of influence in their lives has been all that was required to set that person to refine his/her particular talent. The more the subject is drawn, the more familiar it becomes. The fear of drawing has been removed.

This, however, is only the starting point for us. I can assure you that it is no more difficult to draw a face than it is to draw a cup and saucer, or something as basic as a block of wood. What you do need is the confidence to start and the time to spend on learning

about your subject.

That is all very well, but let us look at the first part: where does the confidence come from?

Confidence grows from knowing how to start, and "Sketching Line" is where our journey begins.

FIRST YOU NEED TO UNDERSTAND YOUR DRAWING TOOLS.

There are a multitude of tools that can create line, and by scribbling with these tools you will learn more about their inherent properties. Whether it is a piece of stick dipped in ink or a watercolor pencil, each will have its own strength and corresponding weaknesses. You must choose which will best suit the subject in hand. Unlike the person who always draws horses the same way, the question you should ask yourself is: "Do they always have to be drawn in pencil?"

SECOND YOU NEED TO "OBSERVE" YOUR SUBJECT.

This is where time comes into play. You must never feel that you are rushed. Sit and look for as long as you need. Try in your mind's eye to simplify what you see.

IS YOUR SUBJECT SYMMETRICAL?

Can you put a line through the center and chop it into equal halves? If you can, drawing the central line first will be a great help in balancing form.

IS THERE A SIMPLE FORM LURKING BENEATH THE COMPLEX OUTER CASING OF THE STRUCTURE?

You may be able to break your subject down into a circle, triangle, or square.

BY USING A SIMPLE SHAPE, CAN YOU ADD OTHERS TO IT LIKE A SET OF BUILDING BLOCKS TO CREATE YOUR SUBJECT?

To begin, it may take you a little while to simplify things to this degree. Once you get going, however, it will become second nature. Immediately you settle down you will begin to make marks that describe your simple vision. You will have begun using Sketching Line.

"Where did my scribbles go?"

While the preceding ideas are your next step in drawing, you don't have to take them until you are ready. Stay with Scribbling Line until you feel ready to move on; let your scribbles develop naturally. Slowly solidify them, until they begin to take form. That is how the flower on this page was drawn, from a scribble moving up the stem to a more solid sketch.

MATERIALS

HB, 2B, 4B Pencil

Graphite Stick

Soft, Medium & Hard Charcoal Pencils

Colored Pencils

Brush Pen

Kneadable Putty Eraser

Heavyweight Artist's Cartridge Paper

Reed Pen

Waterproof Drawing Ink (neutral gray)

Watercolor Pencils

Round Nylon Brush

Reed-embedded Handmade Paper

HB PENCIL

An HB pencil is excellent for further general sketching. Differences of tone are controlled by both a build up of lines and by variations of pressure on the point during application.

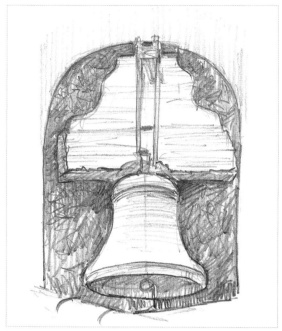

Here the bell is symmetrical. The line down the center helps to ensure that each side is equal. Lines at right angles to the central axis help and allow proportions in the width to be controlled early in the drawing.

RANGE OF PENCILS

Using a variety of degrees — HB, 2B, 4B (various densities of graphite) — gives an added sparkle and clarity to the finished sketch. In this rendering, 4B was essential in the background to give the edge of the light flower (to the right) the contrast it demanded.

Initially, this rather complex subject is broken down to circular and triangular forms. The shape and proportion of the large masses can thus be established before the complications of detail or shading are added.

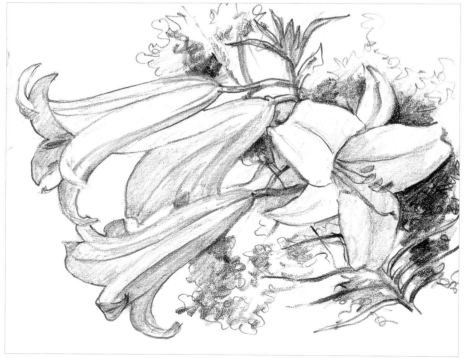

GRAPHITE STICK

A graphite stick by its very thickness does not allow fine line work. The initial oval form must be kept soft; it will then soon disappear under the soft linework that builds up the structure of the figure.

Building blocks can be geometric (cubes, cones, cylinders) or more amorphous. In this case they are loose oval forms that provide the basic stance and balance before more solidity is achieved with the gradual build up of linework.

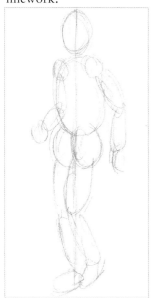

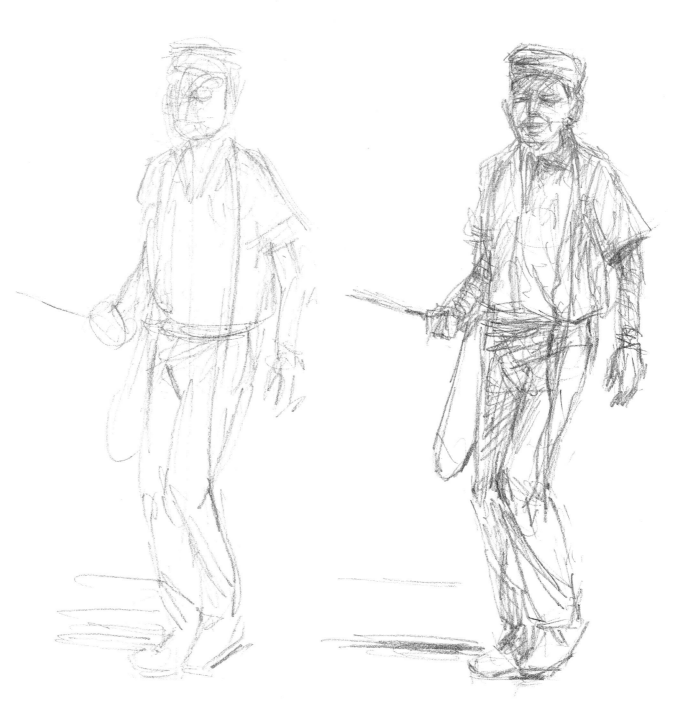

CHARCOAL PENCIL

Sketch out first with a hard charcoal pencil, gradually increasing the softness as the piece develops. Sharpen pencils with a sharp knife to expose a long point. This allows both fine line (point) and soft wide line (edge) from the same pencil. Rubbing a finger across linework not only softens and increases line density but fills in spaces between line, suggesting greater solidity.

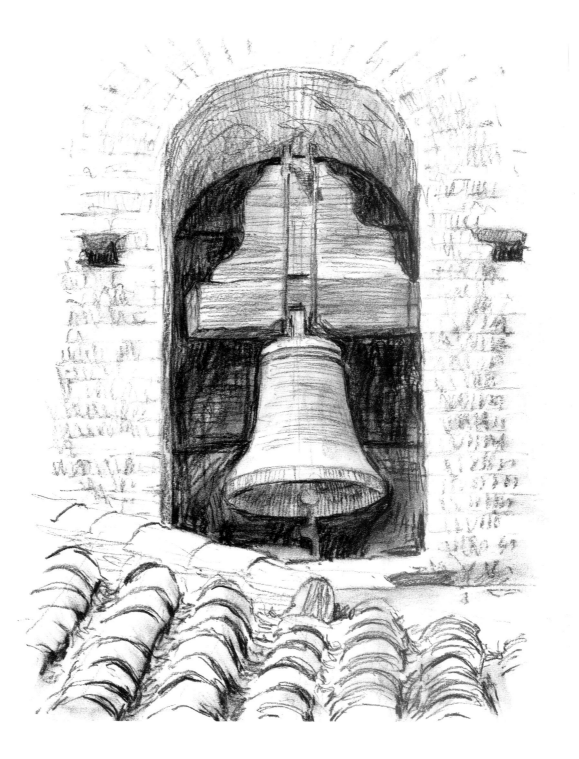

Charcoal is crushed and reconstituted as *Charcoal Pencils*. Controlled degrees of softness are thereby available, impossible in the natural stick.

Once applied, line can be softened on the surface use finger to smudge.

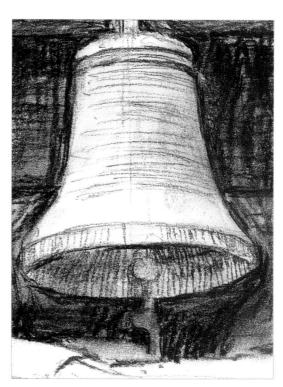

This provides the pencils with a wide variety of line strength, a great advantage to artists.

Remove some charcoal with a kneadable putty eraser and reveal a line with unique quality.

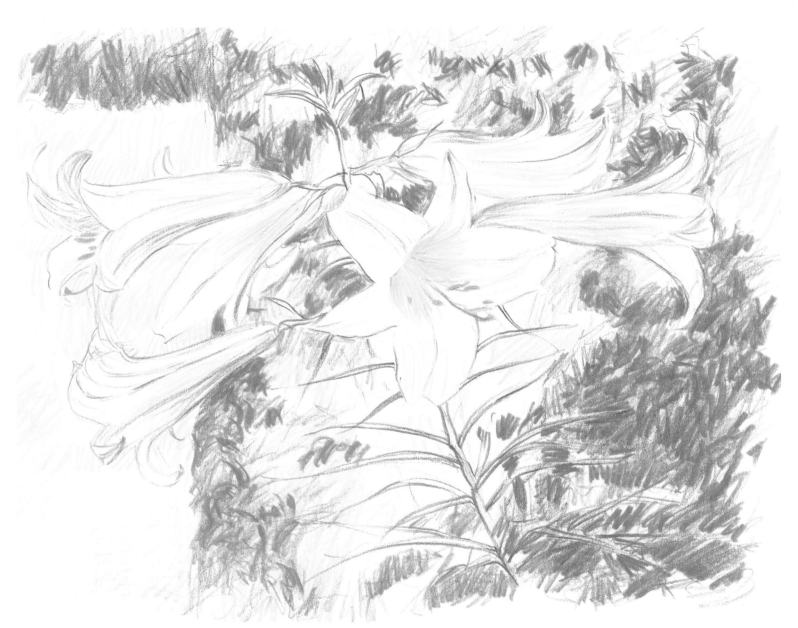

COLORED PENCIL

There is no doubt that colored pencil takes time to build up, but for sketching it is an excellent medium. Easily portable in your pocket or bag, you can now sketch in color. Here the sketch is from a photograph. Great effort was made to keep the linework fresh. Overworking is soon apparent when the color becomes too solid and the pencil line is obliterated.

A light blue "positioning" line will easily be covered over with subsequent colors.

Scribble highlight colors across surface, discovering the patterns of color and the overall color balance.

Tighten up with dark values (in this case a range of greens).

Apply intense spot colors (small dense areas) of line, using more pressure to create accents and focus.

BRUSH PEN

This is another marvellous sketching tool. The brush pen is so much easier to carry than pen or brush with ink. It is so responsive that it is quite a shock to use it for the first time. Have patience, and you will be rewarded with a tool that is exciting and addictive. The fact that mistakes are difficult, if not impossible, to erase forces you to become spontaneous. Your speed will increase as you gain confidence, enabling you to capture those fleeting moments. Note the continuous fluid line used here in the areas of shadow.

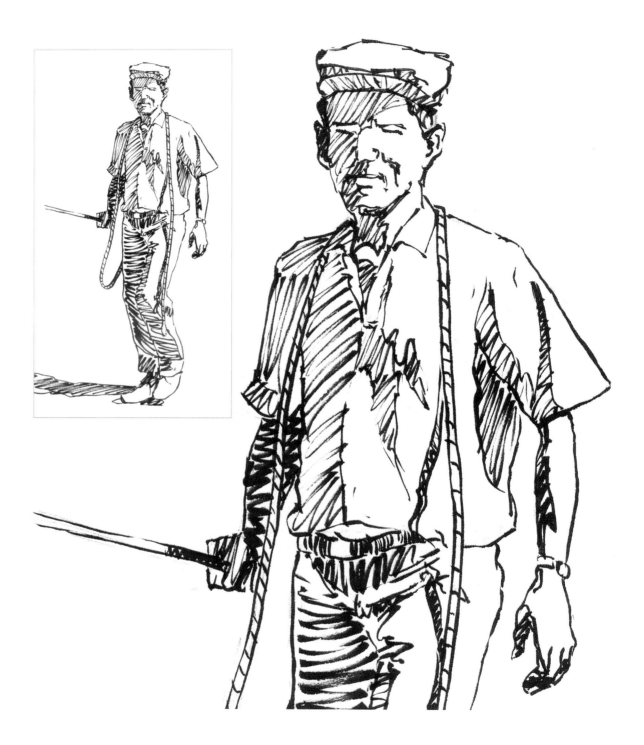

Produce as much preliminary sketching in pencil as you need to give you confidence to apply the ink.

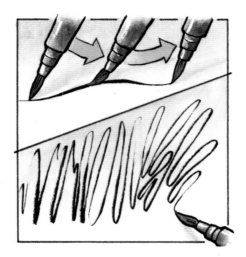

A line responsive to pressure and a continuous ink flow are two natural qualities you should exploit.

Keep initial ink sketching simple and light, little more than the silhouette.

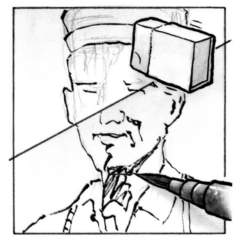

When completely dry, erase pencil work with kneadable putty eraser and complete detail.

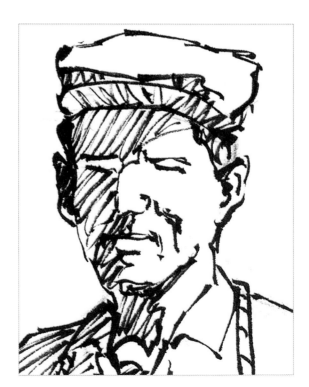

51

Reed Pen and Watercolor Pencil

The flow of ink from a well-made reed pen has to be experienced to be believed. For the examples here, two pens were used. (a) and (b) were created with the same pen, using the pen-point conventionally for (a), with the back of the pen-point for (b). (c) and (d) were made with a larger pen, again conventionally for (c), with the back of the pen-point for (d). (e) shows the hatching possibilities with the fat pen-point (top) and the finer pen-point (bottom). In each case the pen was loaded only once, showing the length of continuous line that can be achieved.

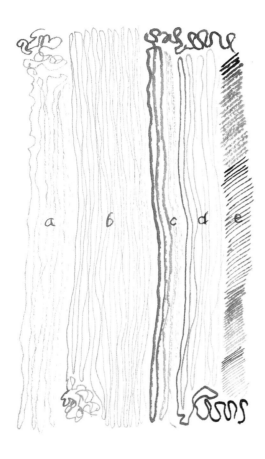

Here the reed-embedded handmade paper echoes the strands of weed onto which Sea Horses cling. Use little or no preparatory drawing. Lightly sketch in shapes, using the reed pen and ink. Slowly reinforce and strengthen line selectively to describe the boney silhouette. Hatched line shading gives solidity to the shapes, with diluted ink employed for the "softened" creature on the left.

Gentle color is required. For this, apply watercolor pencil blended with a large round brush. The absorbent nature of the paper prevents color from spreading. However, the color does intensify when wetted, adding sparkle to the overall effect. Take care not to damage embedded features when working with the watercolor pencil.

MATERIALS

Reed Pen

Waterproof Drawing Ink (neutral gray)

Watercolor Pencils

Round Nylon Brush

Reed-embedded Handmade Paper

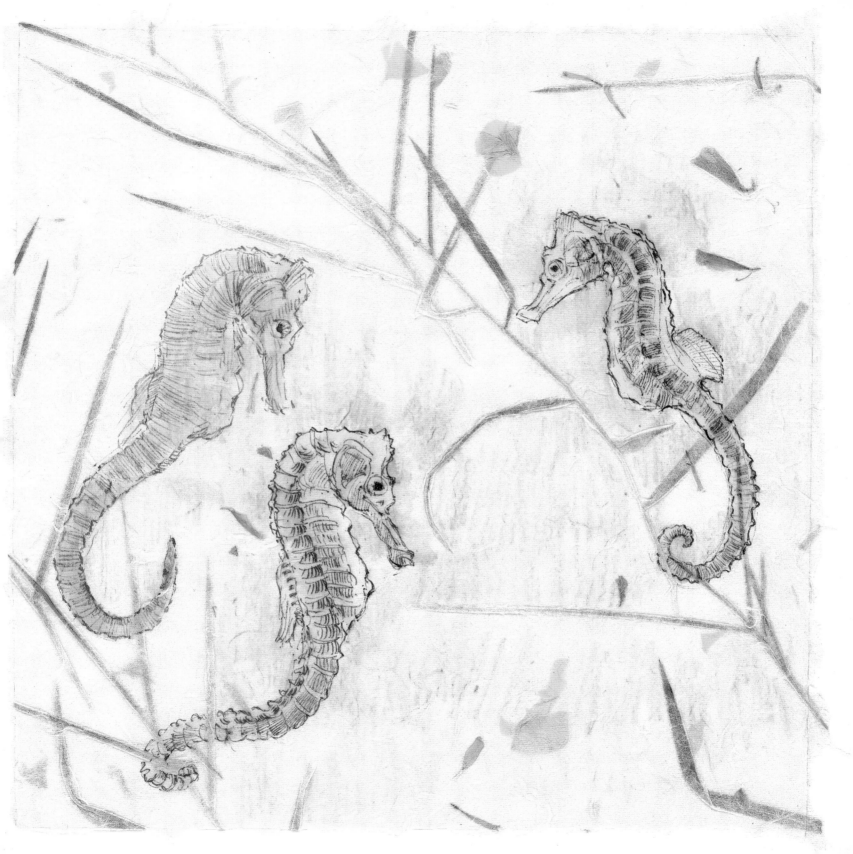

Introduction

We have journeyed through the possibilities offered by first scribbling and then sketching with line. Demonstrating through this gentle introduction, drawing with line should hold no terrors once you have dipped your toes in the water.

While sketching, you will have begun to appreciate the enriching experience of "looking" at a subject, giving yourself time to absorb its essence and structure and that making simple marks that begin to capture its qualities.

These initial marks will at first be tentative. As your skills develop, they will, however, become more and more assured until you are drawn into the world of painting. A world which at the same time brings with it a lifetime of pleasure.

Scribbling and sketching, in of themselves, can be extremely relaxing and fulfilling. But why not develop that line in order to add depth to the subject? It is very simple to turn the line into a descriptive and suggestive one.

LINE AS SILHOUETTE

What does the line drawn around the outside of an object do? Did you ever, as a child, use a stencil to draw the outline of a butterfly or an elephant? Perhaps you were encouraged to draw around your hand with your fingers spread on a piece of paper.

Remember the results? Although this was fun, did it really express much about the subject?

Did the butterfly look light enough to be carried off by a breeze, or the elephant heavy enough to flatten a car? Or did the drawing suggest how rough an elephant would feel to the fingers, or how silken a butterfly would feel?

Was the drawing of your hand in any way suggestive of the incredible softness and strength inherent in it like a hand which at the same time has the dexterity to pick up a frying pan or hold a raw egg without breaking its shell?

The reason that these early silhouettes didn't expand on the intrinsic qualities of the subject was simply because they were not designed to. Drawing around a stencil produces a line of equal thickness. Usually the very point of the pencil is being used to "discover." every nook within the stencil, and it takes all one's concentration to keep the pencil moving and the stencil in place. There is no thought of the subject until the stencil is removed; then it is often a surprise when the subject is actually revealed.

MATERIALS

2H, HB, 2B, 4B, and 5B Pencil

Automatic 0.5mm pencil with a 2B Lead

Kneadable Putty Eraser

Fine & Broad Nibbed Reed Pens

Waterproof Drawing Ink

Watercolor Paper (Hot-pressed)

Watercolor Paper (Rough)

Heavyweight Artist's Cartridge Paper

Charcoal Stick (varying thicknesses)

Pastel Pencils (2 hues of brown)

Compressed Paper Wiper

Nylon Rigger Brush (Sizes 1, 3, 5)

Watercolor Paints

Brush Pen

Round Watercolor Brush

Gum Arabic

Soft Pastel (1 color)

How can a line reveal the characteristics of an object?

A. By simply changing the thickness of the line, we can suggest weight or shadow.

B. By working on textured paper, the application of line can be disrupted and rendered more irregular. The very choice of paper can thus be linked directly to the subject you wish to depict.

C. With pencil line alone, you also have the possibilities offered by all the degrees of softness.

D. By using the same pencil and adjusting its angle to the surface, you can present either the point or the shoulder of the lead.

All these possibilities can be combined to varying degrees, making available a repertoire of strokes from which you select those best suited to the drawing in hand.

USING COLORED DESCRIPTIVE LINE
Play with your pencil for as long as possible before you begin to expand into the world of color. All that has been explored to this point can be exploded into color by the use of other media from colored pencil to inks, and finally into paint. But travel the path at your own pace. Build up the foundation of your ability and confidence before you move on to the next challenge. There is much to discover, so enjoy the journey.

LINE AS SHADING, VOLUME AND TEXTURE ▶
Once you have exhausted the descriptive nature of the silhouette, you can begin to look inside at the light and texture moving across and around the surface of your subject. Learning to create all of the qualities of texture and tone in terms of line could lead you eventually toward the use of scraperboard, lino, and wood-cuts.

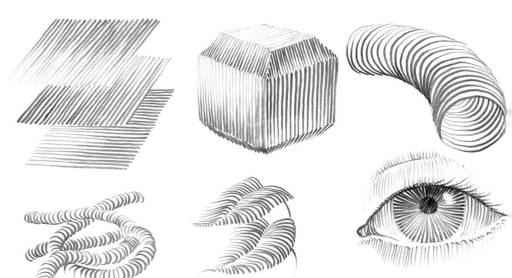

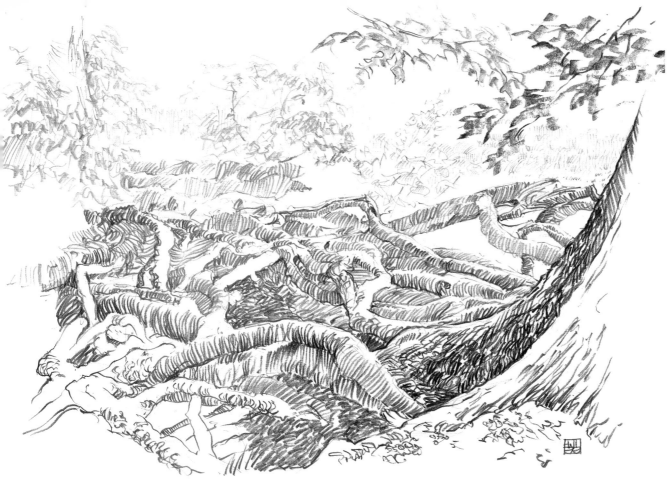

allow you to scribble in the main masses and the direction in which the roots flow. This can be erased later with a kneadable putty eraser where it infringes on highlight areas that require clear white paper to show through. Elsewhere it simply "vanishes" under subsequently applied stronger pencil lines. Two qualities of line are worth noting. The first can be seen in the leaves at the top of the drawing. Here the shoulder of the pencil point produces a very soft line, which swiftly changes from fat to thin, depending as much on its direction of stroke as on the pressure used in its application. Secondly, lines applied parallel to one another — whether straight, curved, even or descriptive — are generally termed "hatching." We will be exploiting hatched lines again and again, often referring to them as "line shading."

PENCIL

A lakeside stroll provides this excellent subject for a pencil study to demonstrate the descriptive power of line. The roots of a tree, exposed by water erosion, create a Chinese puzzle of interlocking roots. Here, the importance lies not in faithfully reproducing every root but in suggesting the quality of the gnarled, rough, lichen coated wood. The line should show not only the form of individual roots but should "describe" a sense of depth or aerial perspective. To achieve this, you will need to employ a range of pencils of varying degrees of softness. Here a 2H, HB, 2B, 4B, and 5B were used.

The hardest [2H] is used for distant detail, where accents are at their lightest. Working from the back of the image through to the front and increasing the density of the marks — achieved through working with increasingly softer pencils to the softest [5B] — reflects Nature. Where accents progressively lighten into the distance, creating depth.

A complex study such as this can go wrong if you simply start at one point and move outward. To avoid bad judgement and unwieldy proportions and to give you the confidence to apply the stronger descriptive line, it is wise to first create a very gentle structural outline on which the drawing can grow. For this, an Automatic 0.5mm pencil fitted with a 2B lead is best. The delicacy of this lead will

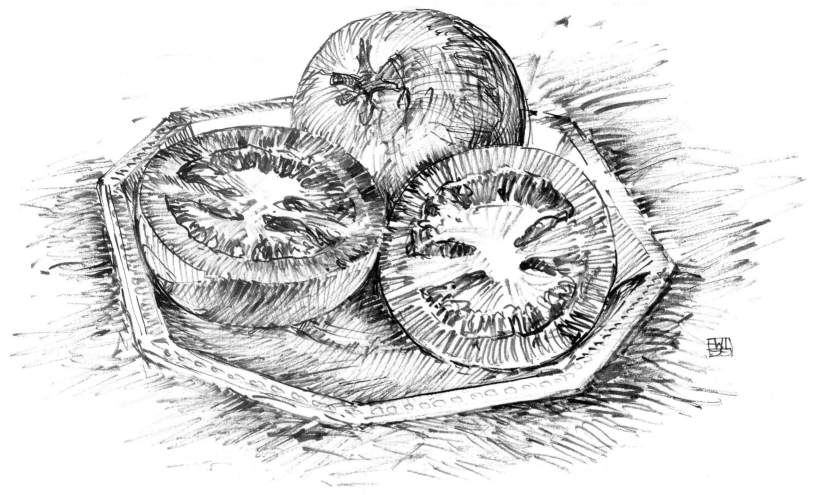

REED PENS AND INK

For this subject I turned to the kitchen. To endow this simple still life of tomatoes on a saucer with a little drama, they are rendered with two handmade reed pens. A small "pen point" for detail and a large "pen point" for soft "dry" lines were used on a very smooth (hot pressed) watercolor paper. Sketch the initial outline with a 0.5mm 2B lead automatic pencil. The brown drawing ink cannot be erased once applied, and this outline is essential to provide the confidence needed to keep the linework loose in quality, yet controlled in positioning.

Reed pens provide a marvellously responsive and fluid descriptive line. When holding a reed pen in the conventional way, the inner surface of the reed is presented to the paper. This inner surface produces a soft line, which is perfect for tonal work. Reversing the pen point to present its back to the paper produces a finer, sharper line, which is perfect for detailing and controlled edge work.

Once the main elements have been established in ink, the pencil outline should be gently cleaned off with a putty eraser so that highlights, or areas in which paper will be allowed to show through, can be seen more clearly. Finishing details can now be established.

A technique worth noting: On the foremost edge of the tomato half on the left, the hatched strokes are pulled down from the edge, reinforcing the contrast at that edge.

CHARCOAL STICKS

Use varying thicknesses of charcoal stick. Establish natural quality of soft fur by smearing. Doing this along a line increases softness and density. Smear away from the edge of the line to make it more powerful. Smear across lines to reduce strength and pull otherwise overworked areas together. Draw fur with a thin stick. Strengthen the silhouette with a medium thick piece. Exploit the power of a really thick stick for the background and "pull" away from the edge of the rabbit to reinforce its silhouette.

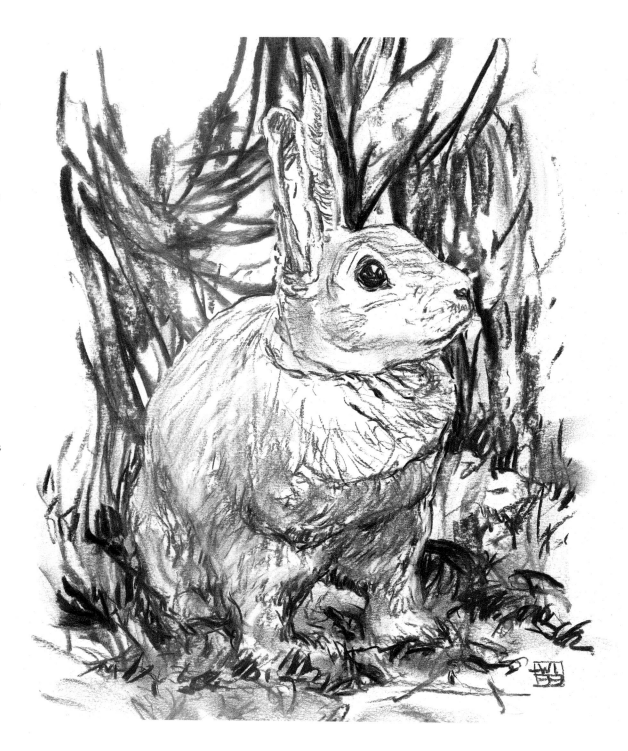

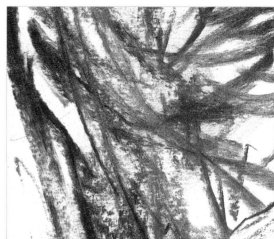

Charcoal Sticks: natural, burnt twigs, available in varying thicknesses.

No need to sharpen. Go with the natural quality of line produced using different pressures.

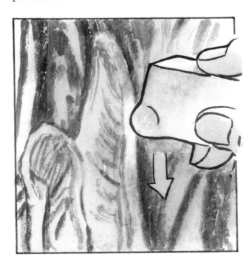

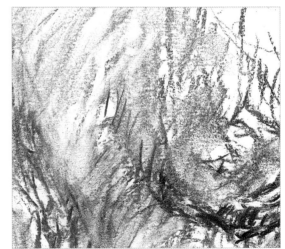

To soften and erase, rub finger across to smear and lift the charcoal.

Use putty eraser to renew highlights. Caution: use sparingly as eraser soils quickly.

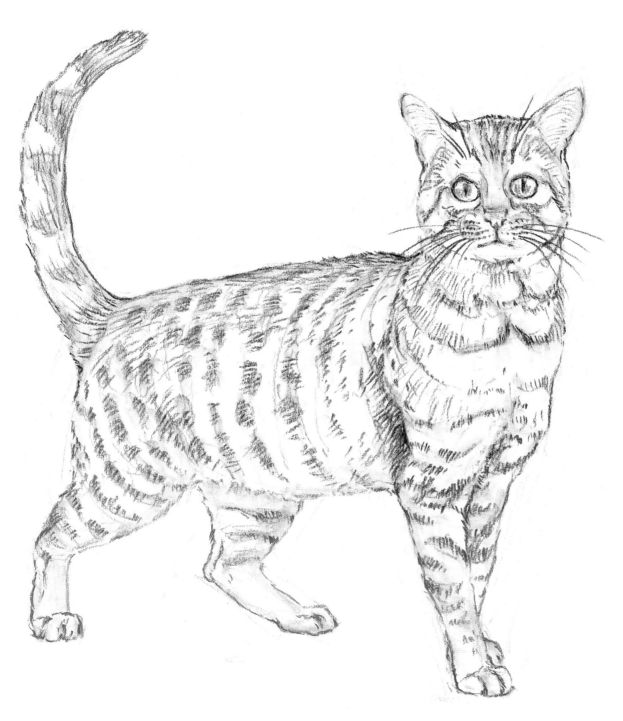

PASTEL PENCIL

Use thick, smooth cartridge paper, two hues of brown pastel pencil, and a compressed paper wiper. Carefully observe negative spaces between the legs to accurately portray the stance, proportions, and balance. Pay attention to line changes along the silhouette. Is the fur smooth or broken? Start with a sanguine line. Reinforce with sepia, which — underpinned by the former — need not be continuous. This gives you further descriptive possibilities along the silhouette, as the fur clings to the form or changes color with surface patterning. The sanguine is blended in parts with a compressed paper wiper to give further variety to the descriptive line as it flows around the animal's form. Sepia linear shading is subsequently applied, following the direction in which the fur lies to further suggest volume.

Gentle sketching line establishes proportions before beginning detailed line.

Point swiftly wears to soft, wide stroke (top). Increase angle for finer line (bottom).

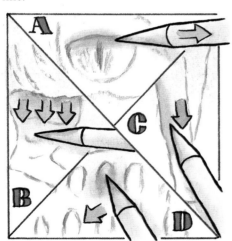

Smearing with stub: (A) Along line, (B) away from line, (C) down edge of line, (D) across line.

Gentle line can be applied heavily first and then partially erased with a putty eraser.

RIGGER AND
WATERCOLOR

Drawing with watercolor affords a fluid line that glides over, and into, surface textures more readily. Adjust the angle of the brush and speed of application to produce scumbled linework. Apply using varying sizes of Rigger. In the Dog drawing, line textures in shadow areas only suggest fur.

The silhouette line "discovers" smooth or broken fur and becomes thicker underfoot to suggest shadow.

The Tree Trunk drawing holds more color, making it easier to express rhythmic nature of the texture. The background is a thinned down wash to suggest distance. Remove original guidelines with a putty eraser to clean the drawing.

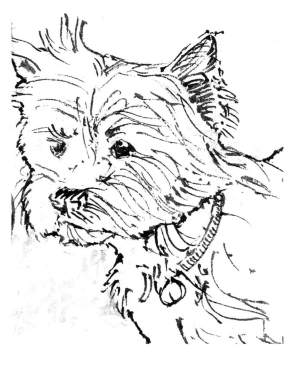

Sketch guidelines. Lighten by dabbing with putty eraser so watercolor line shows up.

With Nylon Rigger, vary speed and pressure to exploit responsive line quality of brush.

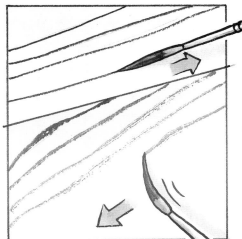

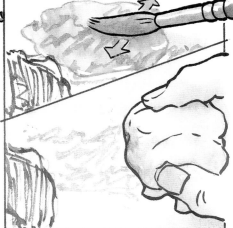

Pull head along to create continuous line (top). Pull head sideways to create scuffs (bottom).

To lift over-heavy linework, "wash" with brush and clean water; dab off with tissue.

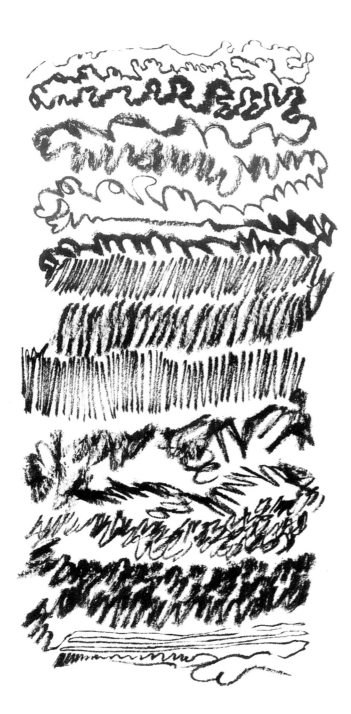

Brush Pen and Soft Pastel

Believe it or not, this is one continuous line made with the brush pen. The variety being created merely by varying the pressure and speed of application, as well as the direction of the brush. A built in cartridge ensures a continuous supply of ink, making it a joy to use. Once dry, the line is waterproof, thus it can be overpainted. It also takes to all kinds of surfaces, and its delicate touch is demonstrated by the fact that with it, one can even apply a signature onto the final layer of a pastel painting!

For spontaneity, no preliminary drawing is necessary. Start off by smearing some soft pastel across the end of your thumb. Stand over your surface to loosen the whole body and boldly applly rhythmic strokes to emulate movements of dolphins and waves. Make adjustments at this stage with a kneadable putty eraser. Fix more firmly by pushing into the surface by first using a paper towel and then with a round brush, loaded with water and gum arabic. This effectively turns the soft pastel into a wet wash. Gum arabic is available as ready mixed watercolor medium (or mix 1 part with 3 parts water for this technique). Switch to brush pen for application of line. Stand again, so that your arm is free to capture the fluid silhouettes. Once completed, introduce descriptive flowing lines to suggest solidity and volume.

MATERIALS

Brush Pen

Soft Pastel (one color)

Kneadable Putty Eraser

Gum Arabic

Rough Watercolor Paper

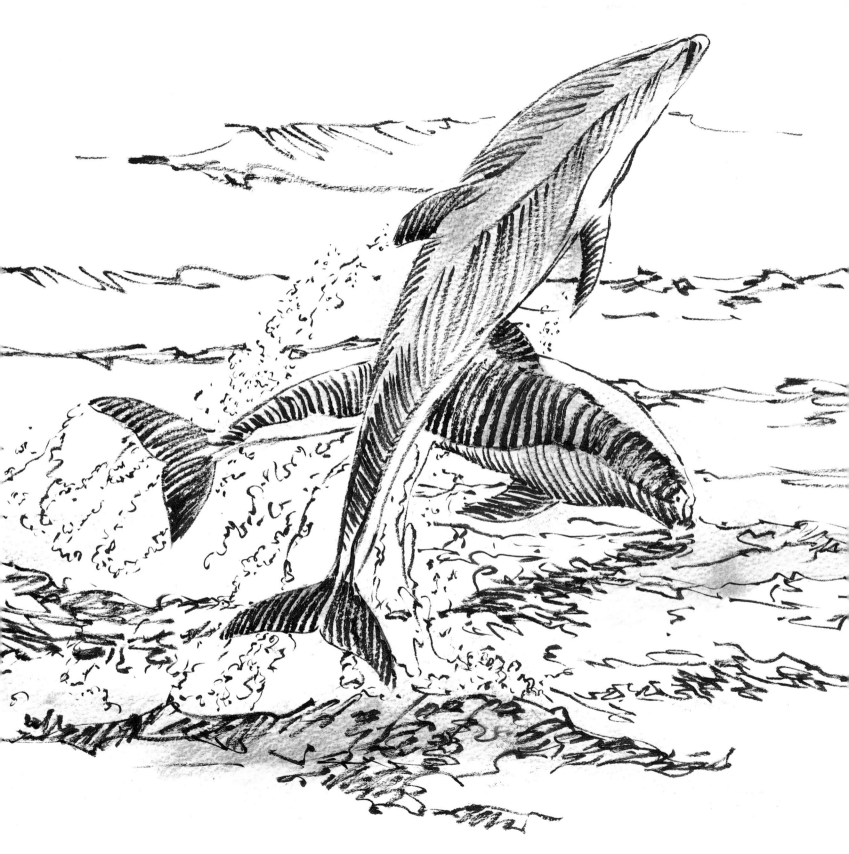

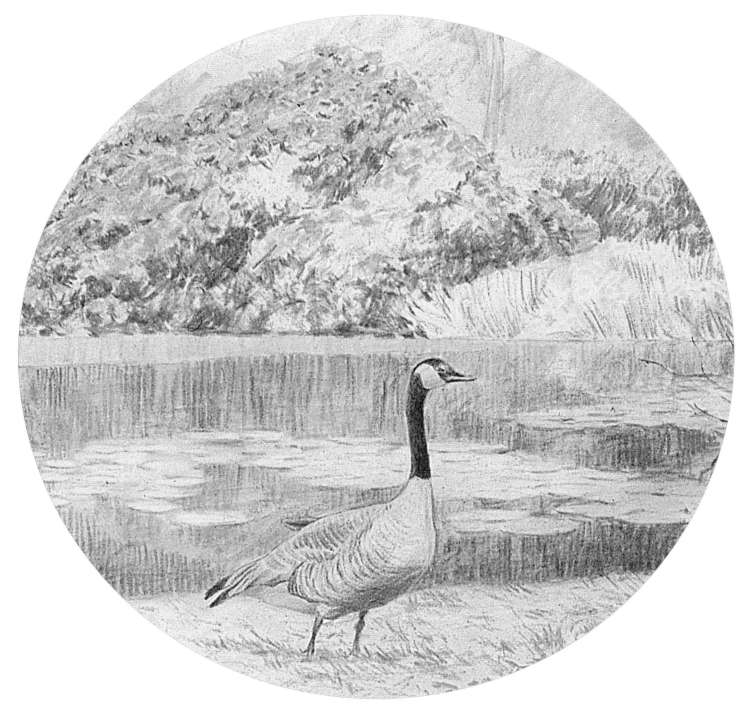

Introduction

Almost everyone today knows the work of Vincent Van Gogh, that tortured soul who brought out the beauty in the simplest of subject matters. His unique visions have spawned a multitude of books in which you can study his work in detail, from his reed pen drawings to his *Starry Night* oil painting.

It is well worth studying this master's work, for it illustrate the essence that you are about to seek to add to the growing repertoire of techniques covered in *Pencil to Paint*.

When standing before one of Van Gogh's works, your eye is immediately drawn into a turmoil of movement. It speeds across the surface, caught in ripples and eddies caused by the linear application of marks — be they made with ink or paint.

These are three-dimensional mosaics of marks and color. Each stroke leads our eye in the direction of another stroke, which leads on again until our mind reels with the excitement of movement.

Subtly, however, our eyes are kept within the confines of the painting by changes in direction of these lines and differing weights of application.

While Van Gogh is the absolute master of this technique, once you have noted its qualities, you will begin to see it in the work of other artists. Monet, for example, creates horizontal strokes across his water lilies and vertical strokes for his reflections.

FROM DRAWINGS TO PAINTINGS

The direction of the line or stroke is an essential element in the success of the finished piece. It can suggest the lie or direction of a surface and give volume or solidity to an object. Variations in weight, fluidity, and density can suggest light, or differences in surface texture.

You may wish to be very controlled in its application or extremely abandoned, allowing things to "happen" on the surface to surprise and excite your imagination. Starting with pencil drawings could lead you on to colored pencil and then on to ink and finally to paints. All you have to do is pick up a pencil and start to make marks.

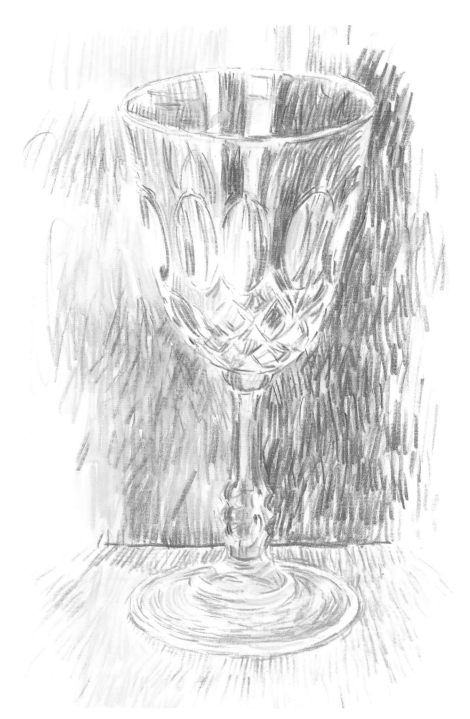

WATERCOLOR PENCIL

Stroked Line

The drawing of a simple object, such as this wine glass, can afford you plenty of opportunity to explore directional line. To achieve sharp definition, work on a smooth surface, such as a good quality cartridge or hot pressed watercolor paper. Keep your pencils sharp and turn them frequently as you work so that you are constantly presenting the sharp edges of the pencil to the surface.

This particular object is symmetrical and thus can grow around a central axis line drawn in a light pink. Measurements are set onto this line ensuring the correct proportions. Complete the overall initial guide drawing, working very gently with the light pink pencil.

Once satisfied with the initial drawing, overlay the bolder directional strokes. Vary their length, direction, and strength to describe the object effectively. Color and value are also paramount, and there is a great interplay between the complementary blue and orange used to work off each other.

To finish off, selectively soften the lines and introduce solidity by brushing along the length of the line with the point of a wetted, round watercolor brush (it should be very soft). The colors intensify as they dissolve and cover more of the white paper in the spaces between linework. Thus the line begins to evolve into a stroke within the same drawing.

Directional lines can be very powerful. Start from one point.

...and create an exciting flow can however lead to distortion. Is this the intention?

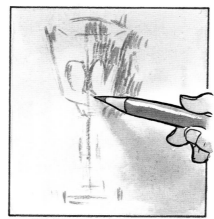

Alternatively, first sketch the gentlest of grids....

....to control positioning of subsequent strokes. Ensure it is gentle enough to be obliterated by these strokes.

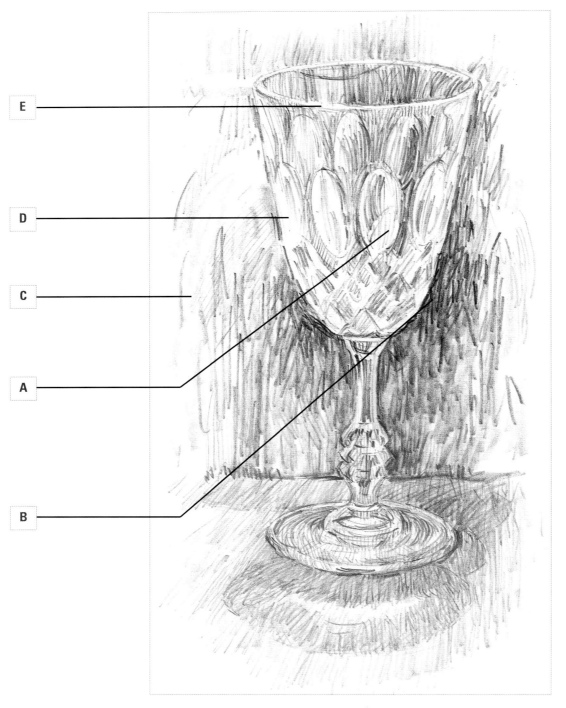

E

D

C

A

B

PENCIL

Directional Line

The tendency when using pencil is to become very mechanical, with tight hatching and cross-hatching playing the part of directional line. Try to keep the wrist loose by continually moving to a spare sheet of paper and simply scribbling to get the feel, and potential, of the marks that can be achieved with the basic pencil. Use a 0.5mm automatic pencil for the initial symmetrical sketch. Don't worry about the complexity of the detail; just enjoy overlaying the heavier line by slowly increasing the softness of the pencil from HB to 6B (A+B), which gives a denser line. A chisel shaped sketching pencil provides wide, bold, brush-like strokes (C), which can be overlaid with finer line. Don't be afraid to use your kneadable putty eraser to clean the drawing, reduce the strength of certain lines (D), or to reclaim highlight areas, such as the rim (E).

PASTEL PENCIL

Directional Line

Pastel pencils afford the softness and fluidity of pastel but with the definition and control of a pencil. Sharpen the point of one color (this example uses sanguine). Lightly sketch the symmetrical skeleton on which the drawing will build. The soft lead encourages you to produce swiftly applied loose directional lines. By altering the angle at which you work and presenting different parts of the lead to the surface, the width of the line is altered. For this to be effective, it is essential that the pencil is sharpened into a long point, cutting away the "shoulder of wood" to allow the side of the lead to reach the paper. Take care when using side-on that over enthusiastic pressure does not snap the lead. Moving the pencil rapidly over the surface from one area to another excites the line and your imagination. Let yourself go! Pick up speed and just see what happens. To turn selective lines into stroke, blend with your finger or paper wiper, working in the direction of the line.

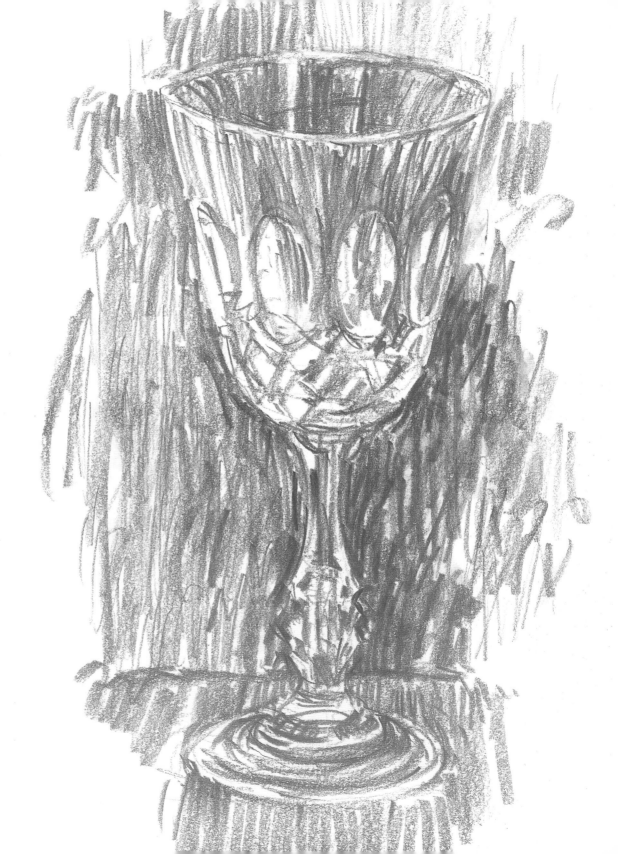

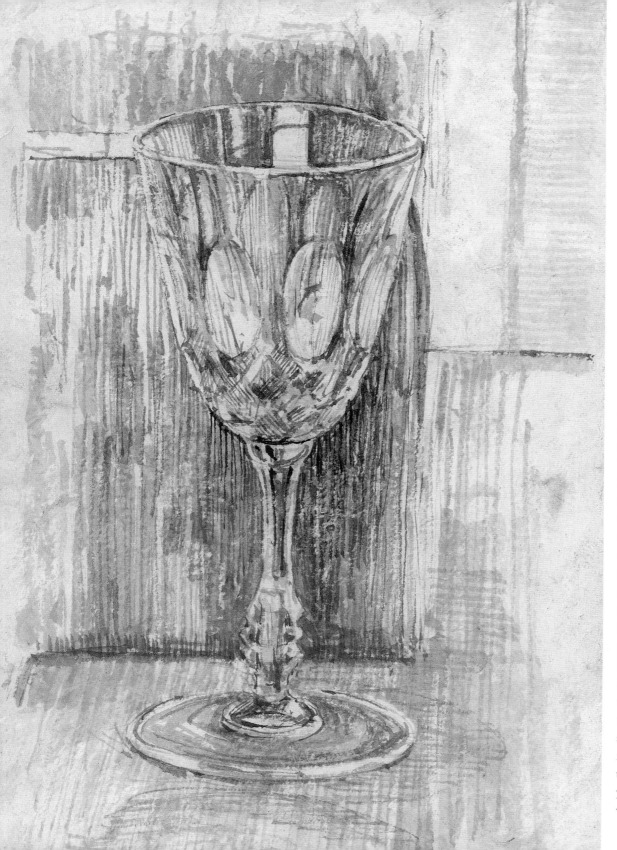

WATERCOLOR

Directional Line

For line strokes with a brush it is possible to be adventurous and use papers that would otherwise be deemed unsuitable for watercolor. Here an absorbent bark paper is used, and the line, sinking into the paper fibers, becomes permanent almost immediately upon application. Mix a sufficiently large quantity of one color to see you through the exercise. Complete the first guideline sketch very gently by letting down some of the color into a very thin wash. This is easily covered by a subsequent stronger line. Try alternating brush shapes, from a fine line rigger to a more conventional round brush that produces a thicker line. There is now tremendous variation in the nature of the line. Pulled rapidly across the surface, the line will become a textured scuff (scumble). Each line can vary in width, along its length, depending on where pressure is applied. Pulling strokes from edges will define the latter, as well as developing texture and value (light and shade). Building up the line by slowly increasing its strength can be tremendously rewarding. As you move around the internal structure of the glass, you are truly "taking the line for a walk".

SKETCHING PASTELS: COLOR FAMILY

Directional Stroke

Sketching pastels are harder and cheaper than the soft pastels. Seldom available as individual colors, boxed sets are ideal for those wishing to try their hand at pastels for the first time or for those wishing to travel light. Being faced with a limited choice of colors, it is tempting to use them all. This, however, results in garish images. It is best to limit them even further by working in a family of close colors. By all means use white and black, although the latter should almost always be overlaid with a second color to prevent it becoming dominant. Having said that, Degas, the master of pastels, often used black as a sparkling accent to enhance the color balance of his pictures. This exercise uses a range of browns plus white on colored pastel paper. When working with a limited palette, try not to overpower the paper color. Use it as a color in its own right between the colors you apply. Pastel paper not only provides a color on which to work but also a unique texture and a tooth, which will hold the powdery pastels strokes.

Start with a midvalue close to that of the paper (A) so that corrections will not seem too dramatic. Hold pastel like a pencil and use tip for bold lines and strokes. The direction of each of these builds the picture, so no need for blending (B). Vigorous working mixes colors on the surface and also pushes them into the tooth, consolidating the surface (C).

As the pastels are hard and thus require pressure in application, only a limited number of layers is possible. Avoid layering color on highlight areas for as long as possible so that the white, when applied, will stick to the surface. Achieve all you can with the mid tones and darks to establish the drawing before turning to the white. This can begin as soft, wide strokes (D) and end as sharp, heavily laid sparkles of light (E).

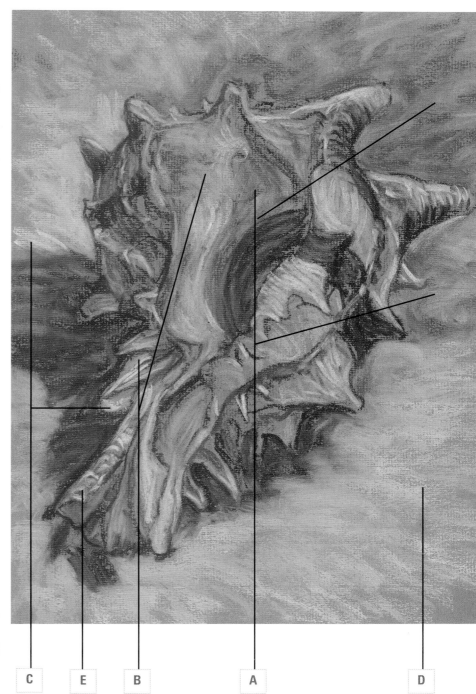

C E B A D

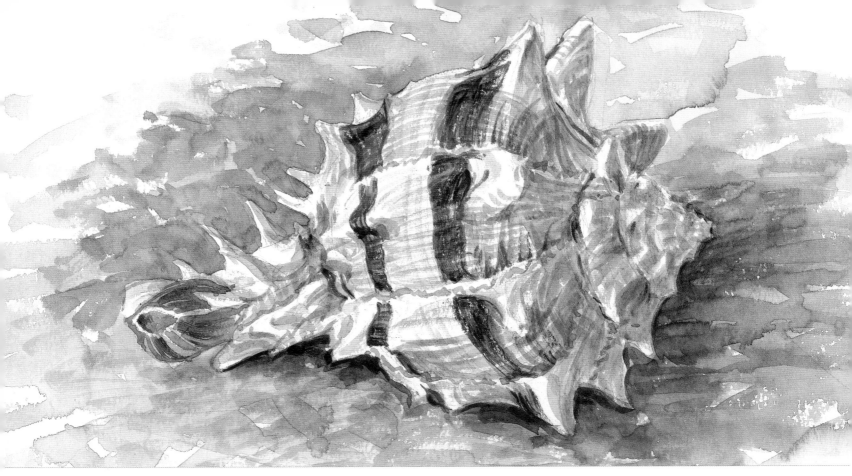

WATERCOLORS: COLORED GRAYS

Directional Stroke

The primary quality of watercolor is its transparency. As the strokes are woven across the surface, they all remain visible. Color is seen through color, as the values slowly darken. While dry brush strokes in the form of scuffs (scumbles) remain separate, the more fluid strokes will flow together. When working

Wet-on-Dry (wet paint on dry surface), the edges of the brush marks become very sharp and distinct, even with the gentlest of color mixes. For best results, work on a watercolor paper. There will be quite a difference working on an absorbent paper that is well sized and stays wet. Play around with different papers to see which effect you prefer.

Here a 300gsm Not, well-sized paper was used. One medium sizeded round brush — either sable or sable/nylon mix — is all you need to apply the color. Using one size prevents you from becoming too fussy and forces you to be inventive. Remember to use visible brush strokes as you work vigorously across the paper.

Color mixes are kept as

close to gray as possible. In each case, first identify and mix the color of a particular area; then add its complementary (opposite on the color circle) until the color dulls and darkens to almost gray. Often the color will then have become too deep, in which case extra water is required to make it the correct value (strength).

Exercises such as this not only give you confidence

to apply wet-on-wet strokes freely and descriptively, but are also ideal for color mixing and identification. The most exciting overlaying of strokes appears as opposite color temperatures are overpainted (in shadows). As the colors become darker, allow them to become drier by adding less water. The scumbles that result allow the colors beneath to show through between the darker textures.

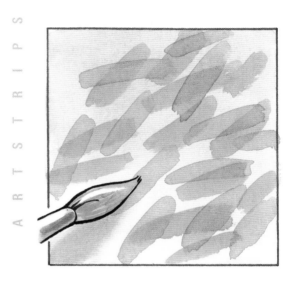

Transparency of watercolor allows all strokes to remain visible.

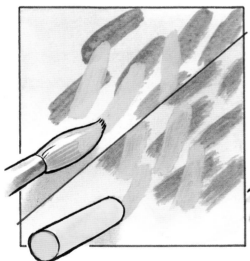

Opaque mediums (oils and pastels) can obliterate the strokes beneath.

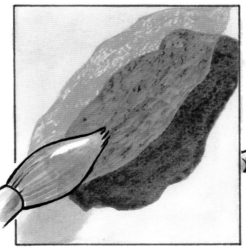

And thus rely more on scuffed or thin strokes that only partially cover underlying brushmarks.

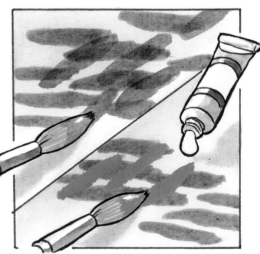

Acrylic can be transparent or opaque, depending on the quantities of white added to the mix.

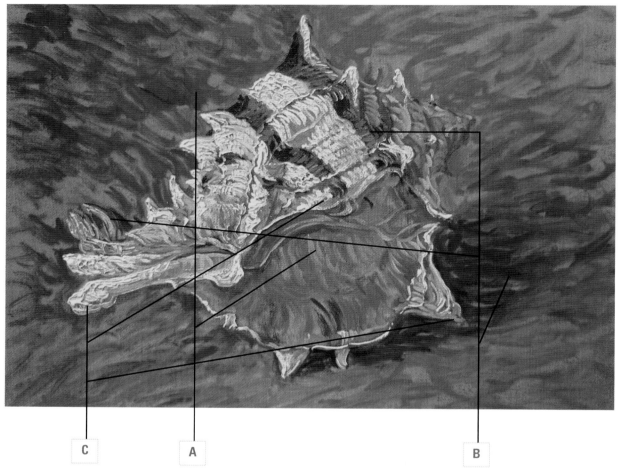

C **A** **B**

stands, but also a contrast of value which changes along the silhouette of the shell (B).

Paint in layers from the dark drawing, through the lighter values to white. While the darker blues had orange added and vice versa, the lighter blues and oranges do not need this reduction of intensity. Adding white takes some of the brightness from the colors. Final lights are given a small amount of oily thinner, for a flowing line that is still thick enough to rise from the surface (C). Use a small nylon brush to give finer, more responsive stroke.

While narrow deep strokes can overlay the wider, shallower ones, it is important not to overwork. Too much overpainting and the strokes may begin to blend overmuch, and the fresh, brushy quality will be lost.

Oils : Color and Temperature
Directional Line
Work upright and cover the surface in a thin layer of oily thinner mixed with a touch of dull green [Bp+Yo+UW] to provide a fluid surface into which you can lay

your brushstrokes. By eliminating the white surface, it allows you to work color against color. Mix orange and blue in differing amounts to produce warm browns and cool blues. The result is a painting which relies on the variations of

color temperature, as much as values, to suggest volume.

Shadows are kept cool against the warm lights throughout.
With the point of a bristle brush, apply dark to middle values first.

This produces a distinctive striated stroke (A), particularly where colors are only partially mixed. Constantly add oily thinner to mixes to keep color fluid.
Background blue not only provides a surface on which the shell

ACRYLICS: PRIMARIES

Directional Stroke

Working on a white textured ground has the effect of breaking up individual brushstrokes, making them more exciting to the eye. To explore this idea, first texture a surface. Here the backing card stock of an old sketchpad was covered with a fine layer of acrylic texture (modelling) paste, applied with a bristle brush whose bristles effectively score the paste. When dry, a thin layer of white acrylic paint is applied to even out the color.

This exercise is extreme in that it uses only unmixed primaries, Ro, Bp, Yo, with the addition of white. Two applications of this color sequence are overpainted. The intent being to visually mix them on the surface and to parallel the colors in your subject. You will also find it liberating to apply strokes and colors, which — while at first may seem almost random — will slowly coalesce into a structure with definite form and texture.

Start with an outline drawing, using light blue. Fill in the values with the same color, using directional strokes to create volume. With a bristle brush, draw in the direction of the stroke to now apply the red, followed by the yellow layer. The strong red is the most difficult to apply, being that it is so intense. Be patient. The subsequent layers will dampen each other down.

The technique really only starts to work when the majority of the white surface has been covered. Acrylic is a perfect medium here, since the colors dry fast and there is little chance of any physical blending, so you can immediately start your second layer of blue, red, and yellow.

Toward the end, when the masses have been established, the strokes can be allowed to drag or scuff more, allowing undercolor to show through. The final yellow highlights have a little acrylic texture paste added to their mix, which provides body and raises them from the surface to catch light.

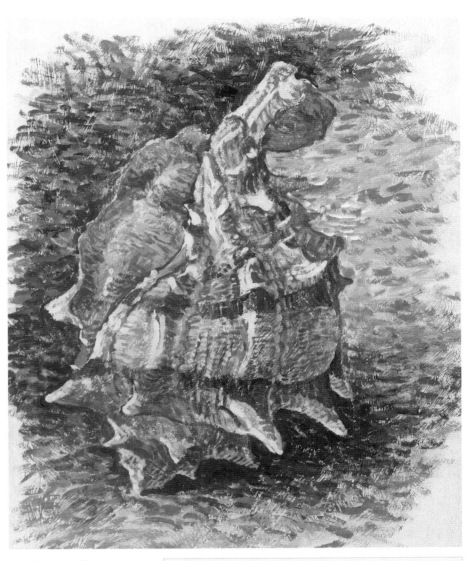

COLOR REFERENCE GUIDE
Red-orange [Ro]
Blue-purple [Bp]
Yellow-orange [Yo]
Underpainting White [UW]

Dip Pen and Drawing Ink

Hatching and cross-hatching is where the dip pen comes into its own. The drawing pen-point comes to a point. While there is a little variation with different pressures, swift freehand and parallel lines are most effective. The hatching and cross-hatching can be either loose or very mechanical.

Note how at the bottom of this exercise you can see the effect of the italic pen-point on the line, where a change of direction means a change of line thickness. The italic pen-point, used edge-on, affords the finest of hatching (downward strokes at base).

MATERIALS

Dip Pen & Pen-points

Waterproof Drawing Ink

(neutral gray, burnt sienna, indigo, yellow)

Round Nylon Brush

Hake Brush (for wetting paper)

Automatic Pencil 0.5mm lead/2B

Kneadable Putty Eraser

Masking Fluid

Rough Watercolor Paper

Toothbrush

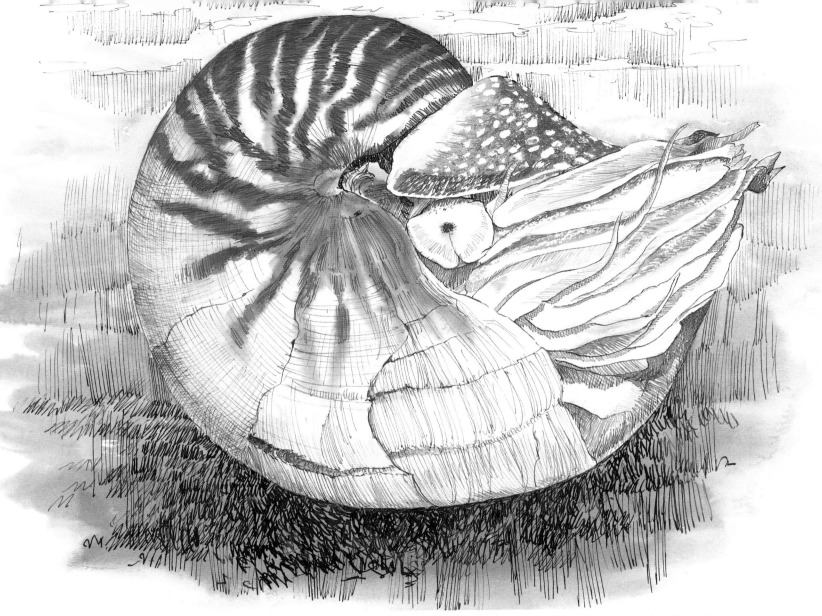

The curve of the nautilus shell is exquisitely subtle, and it is, therefore, sensible to gently sketch the basic shape in pencil before beginning. With a fine pen-point in the pen, carefully outline the forms, using a neutral gray drawing ink.

Remove the original pencil guidelines using a kneadable putty eraser.

Protect highlights and patterning on the shell lid and tentacles with masking fluid and scumbles and smooth strokes with brush spattering with toothbrush. Apply brown and blue washes wet on wet, but beware: ink stains much more swiftly than watercolor, so you must be speedy. For the denser hatching underneath the shell, switch to a wide, italic pen-point.

Ink line on the shell in this example was applied in different colored inks (burnt sienna, yellow, indigo, and a thin neutral gray). Hatched lines create volume and growth lines across the brittle surface. Keep linework to the minimum on the tentacles, as these are lighter and softer in texture.

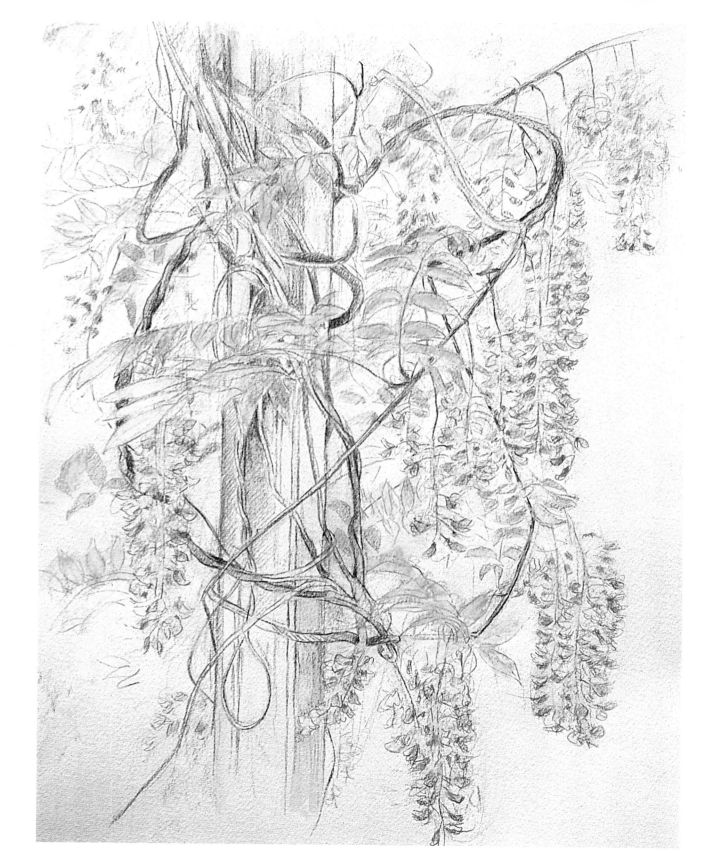

LINE OR COLOR?

Introduction

Most of us can remember the first time we were given a box of colored pencils and the possibilities that they seemed to offer. For most of us this was the first foray into the use of color. Even the smell of a new box of pencils, with their pristine colored coats arranged in rainbow ranks, stirs up memories that cannot be replaced. Even now, I still feel a pang of regret on using the first pencil from a new set, and I certainly find it a strain to sharpen them and shorten their length!

They are, however, the tools of an artist's trade, and it is the use to which they can be put to is far more important than how pretty they look in the box. It is a privilege to utilize such a beautiful medium, and they provide a rich element in an artist's heritage and long usage.

These are our first steps into a world of color. Using pencil provides a very controlled way to apply line, but it is also relatively slow. The confidence that it will build in its user can soon be transferred to tools which offer more speed and fluidity.

First, there are watercolor pencils and crayons, which can be applied into a wet surface or softened afterwards with washes of water or color.

Then there are all kinds of pens that can apply colored inks or paints — all of these materials being easily sourced and carried around.

Moving into color opens up a world of possibilities and inspiration.

The use of colored line leads naturally into colored stroke. Once you understand the power and descriptive qualities of a colored line, these properties can be harnessed to good use with a brush; for a stroke can be more or less seen simply as a fat line. All you need is to give yourself time to acclimatize to the different feel of the brush between your fingers.

This is the stepping point into painting, but it is not a great leap; rather a gentle evolutionary process that is a wonderful moment in your journey toward becoming an artist.

MATERIALS

2mm Clutch Pencil

2B Lead

0.5mm Automatic Pencil - 2B Lead

2B Graphite Pencil

2B Graphite Stick

Colored Pencils

Watercolor Pencils

0.1 Fiber Tip Pen

Dip Pen

Reed Pen

Rigger Brush

Round Brush

Indian Drawing Ink

Burnt Sienna

Drawing Ink

Gouache Paints

Watercolor Paints

Kneadable Putty Eraser

Hot Pressed Watercolor Paper

Colored Pastel Paper

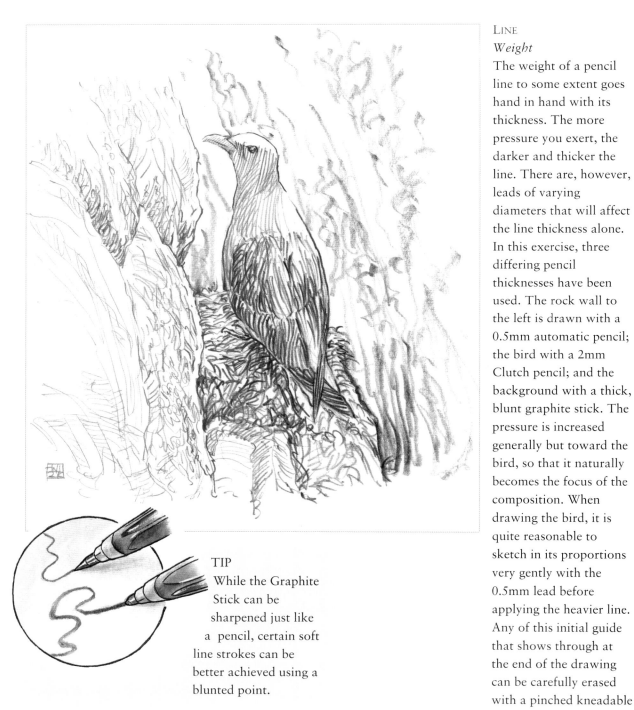

TIP
While the Graphite Stick can be sharpened just like a pencil, certain soft line strokes can be better achieved using a blunted point.

LINE
Weight
The weight of a pencil line to some extent goes hand in hand with its thickness. The more pressure you exert, the darker and thicker the line. There are, however, leads of varying diameters that will affect the line thickness alone. In this exercise, three differing pencil thicknesses have been used. The rock wall to the left is drawn with a 0.5mm automatic pencil; the bird with a 2mm Clutch pencil; and the background with a thick, blunt graphite stick. The pressure is increased generally but toward the bird, so that it naturally becomes the focus of the composition. When drawing the bird, it is quite reasonable to sketch in its proportions very gently with the 0.5mm lead before applying the heavier line. Any of this initial guide that shows through at the end of the drawing can be carefully erased with a pinched kneadable putty eraser.

MATERIALS

Pencils: 0.5mm, 2mm, 2B

2B Graphite Stick

Kneadable Putty Eraser

Hot Pressed Watercolor Paper

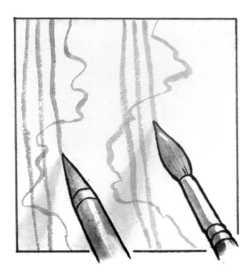

LINKS FROM DRAWING TO PAINTING
Tip of pencil creates fine graphite lines.
Rigger brush echoes this in paint or ink.

Graphite stick point provides sensitive, descriptive lines. Round brush echoes this in paint.

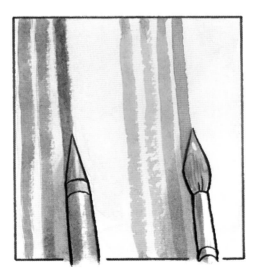

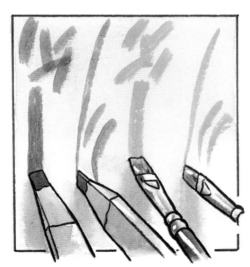

Using side of graphite stick or brush head yields bold or textured strokes, depending on pressure or paint load.

Flat brush echoes flat sketching pencil.

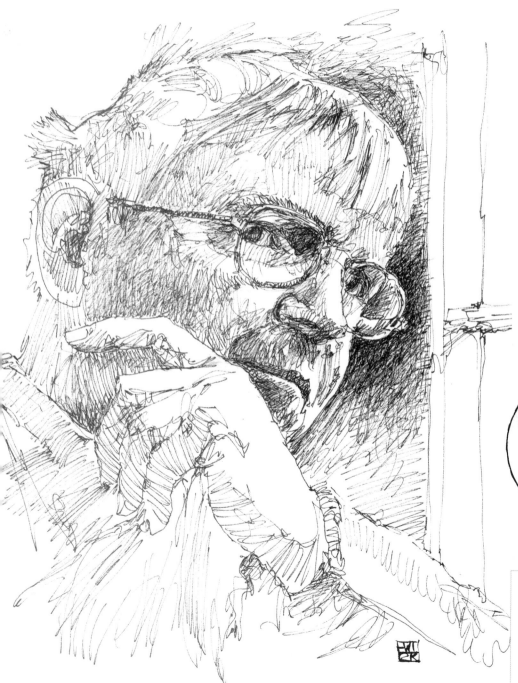

LINE

Density

The 0.1 fiber tip pen produces a line of almost uniform thickness. Here, this is combined with the effect of a continuous line drawing. These are wonderful to produce, the principle being that the pen is not lifted from the surface until the drawing is complete.

While this can be felt to be intimidating, the technique forces you to think and to be inventive in the way the drawing tool is moved across the surface. As the fiber tip ink is indelible, panic can set in, but the line builds slowly. As the layers build, the drawing emerges. In the areas where the density of lines is stronger, the values become darker. These contrasts or accents draw our eyes, focusing them on these spots. Guideline sketching beneath should be kept very light in order to avoid conflict with the subsequently applied ink line. Again, these guidelines should be subsequently cleaned off with the eraser.

TIP

The fiber tip pen differs from an ordinary felt tip in that a metal sheath protects its point. Ensure the pen you work with features lightfast and waterproof ink.

MATERIALS

0.1 Fiber tip Pen

Kneadable Putty Eraser

Hot Pressed Watercolor Paper

LINE

Strength

This rather complicated composition, with so many overlapping shapes and differences in depth, requires a variety of line strength to guide the focus of our attention. In the foreground, the wall and front part of the bridge are made in full strength ink. The grassy banks, bushes, and road are produced with ink whose strength has been let down with varying amounts of water. Our eyes naturally alight on the strongest tones that dominate.

The right-hand tree behind the bridge is executed in full strength ink, which is gradually let down with water so that the other tees, the buildings, and the wood on the horizon become lighter. This suggests aerial perspective in which tones lighten as they become distant. Thus, we are able to control focus and depth by means of adding water.

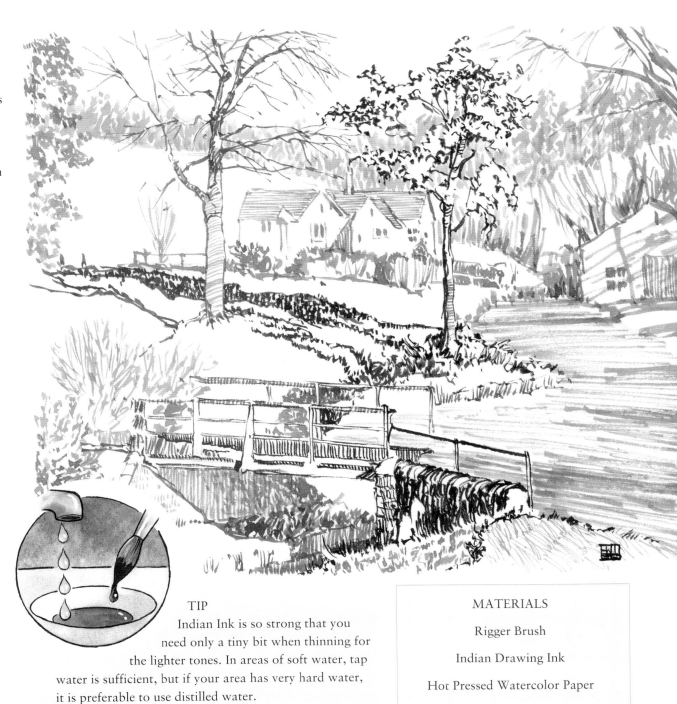

TIP

Indian Ink is so strong that you need only a tiny bit when thinning for the lighter tones. In areas of soft water, tap water is sufficient, but if your area has very hard water, it is preferable to use distilled water.

MATERIALS

Rigger Brush

Indian Drawing Ink

Hot Pressed Watercolor Paper

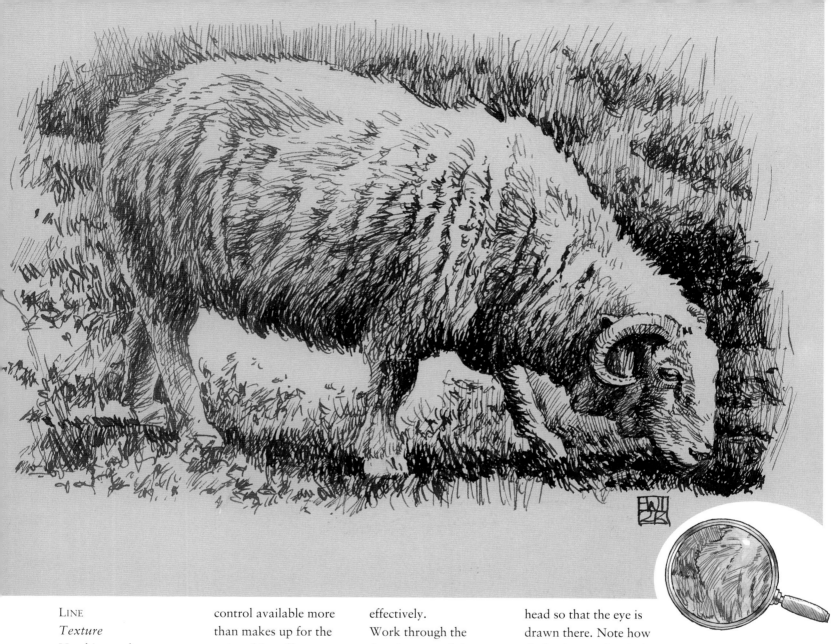

LINE

Texture

Hatching and cross-hatching can be achieved in a very controlled way with a dip pen and can be tight and mechanical where necessary. The technique requires patience, as it does take time. The degree of control available more than makes up for the painstaking effort involved. Again, a gentle pencil skeleton can precede the ink work, although it is well worth erasing as soon as possible so that the contrasts of line shading can be modulated effectively.

Work through the drawing several times, building up layers of hatching gradually. Here the back of the sheep (light against dark), its belly (dark against light), and the shadow on the grass are gradually strengthened toward the head so that the eye is drawn there. Note how the background is darker behind the head than at any other point around the silhouette. More work is done to the drawing here so that our attention remains captured by the detail.

TIP

Each pen mark is a miniature directional stroke, giving form and volume as well as texture.

MATERIALS

Dip Pen

Burnt Sienna Drawing Ink

Colored Pastel Paper

A R T S T R I P S

THE FIRST STEPS TOWARD PAINTING
Using a colored pencil brings an extra
dimension into play.

Felt tip pen colors can be mixed by
overlapping strokes.

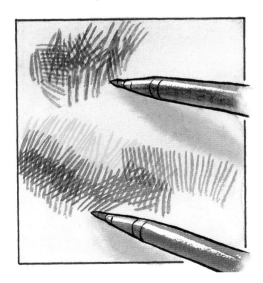

Advantage of dip pens can be used with
black or any color inks and paints.

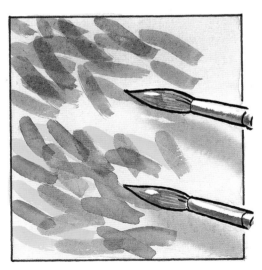

Monochromatic or colored brush strokes
are simply "fat" lines.

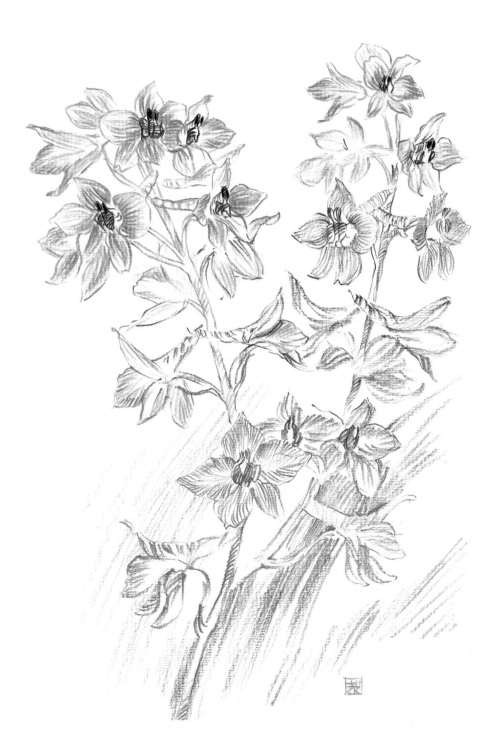

COLOR

Gray or Colored Line?
There is always the choice of whether or not the line should be colored. This exercise is completed using hatching and directional linework to suggest the form and then the color of the petals. At its base, the flower stalk is fluidly and loosely hatched, using the side of the pencil head.

Further up, the point begins to provide a finer line and thus more accurate or focused detail. Hatching with the side of the pencil lead, the internal flower heads and stem are worked in a simple color, using a medium blue and dull green. Edges are still contained with simple pencil linework using the point.

Heavy pencil next to color can easily dirty the overall effect, especially shading when using the rubbing motion — which is natural to pencil. A small amount of pencil "line" shading is possible, as the color then still works against the bright "white" of the paper. At the very top of the drawing, all line contour is completed in color, including the edge outline and the dark centers (sepia) using pencil point throughout.

MATERIALS
2B Graphite Pencil
Colored Pencils
Colored Pastel Paper

TIP
Individual strokes can vary in thickness along their length by changing the angle of application during the actual stroke.

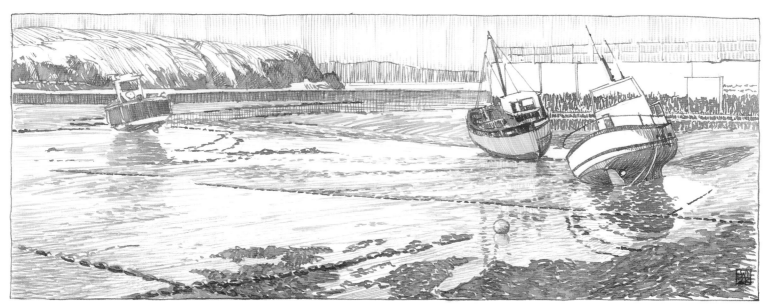

COLOR

Spot Color

Every artist wishing to fully exploit line should experience the fluid strokes of the reed pen.

Above they are harnessed with just two colored inks, not three, as it would appear.
The first being a brown, applied straight from the bottle to draw all solid objects. Brown is often a composite color, derived from the mixing of orange and blue.

Interestingly in this case, it is the orange that stains the paper first. As the ink dries, the blue also penetrates, but if the ink is prematurely dabbed off with a tissue, the blue is removed. On the distant sandbanks a swift dabbing allows only a light stain of orange to remain. Elsewhere, a longer time period left before dabbing creates a more dense effect. The effect can be adjusted by working with a damp brush before dabbing (cliffs) or by working into the dabbed color with darker linework (keel of white boat).

The water and sky are both a watered down brown, without any dabbing. A spot color of yellow linework focuses attention on the center boat, whose color made this subject attractive.

TIP

The same reed pen provides a choice of two line thicknesses, depending on which way up the "pen-point" is applied to the surface.

MATERIALS

Drawing Ink

Reed Pen

Hot Pressed Watercolor Paper

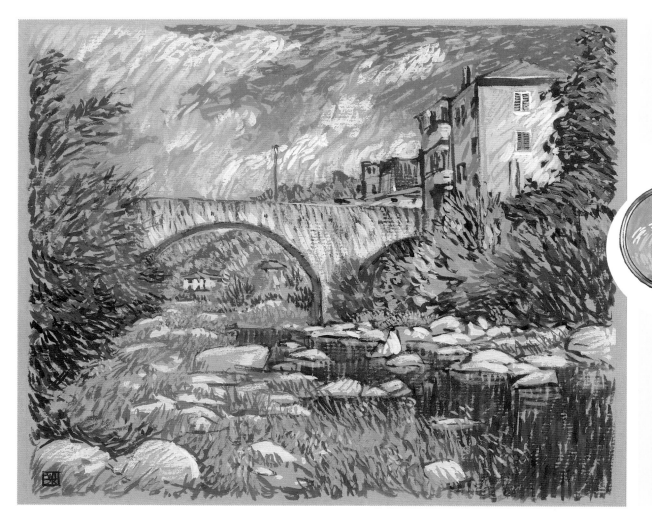

MATERIALS

Gouache Paints

Colored
Pastel Paper

TIP
Not only do individual linear strokes give direction to the eye, it is also the manner in which they are grouped that develops movement across the surface.

COLOR

Directional Stroke 1

Take a walk on a wet night and look at light through the fine wet branches of a tree. Notice how the light seems to select branches at right angles to its origin, creating a web effect with the light at its center. This selection of directional lines is something the artist can use to his/her advantage, although it does take some practice to look at the world in this way. Van Gogh exploited this technique to its utmost, and it is a joyous and exciting way to capture a subject.

In this example, gouache was used on colored pastel paper so that opaque colored linear strokes could be overlaid where necessary. Most of the strokes are simply laid next to one another, starting with the darkest values and slowly working toward the highlights.

The directional lines can be seen to carry the eye along, being most effective at the edge of the composition. Here they turn the attention back toward the center of the composition and hold the painting together in a very positive way.

COLOR

Directional Stroke 2

This idea of the selection of linear strokes is now carried into watercolor in this busy fishing boat scene. Once again, the eye is contained within its perimeter by curved strokes, while across the boats directional lines suggest their structure.

It is difficult to copy from an example such as this, where the focus selection has been so specific — as all you can do is reproduce the strokes themselves and this would lack spontaneity. Find your own reference and make your own focus selections. Here the rippling movement is created with the linear strokes applied wet-on-dry using the point of the brush head.

Watercolor is transparent and strokes will show through one another, but don't be tempted to build too many layers. Laying many of the color strokes next to each other, rather than overlaying them, retains the freshness. This keeps the colors nice and bright, which suits this subject. If you subject is duller, you could overlay more. The jigsaw of strokes soon begins to suggest detail where there is none, so step back frequently from your painting to ensure you are not overdoing them.

MATERIALS
Watercolor Paints
Colored
Pastel Paper

TIP

Deep pools of fluid color dry with an especially dark edge. This can give them a jewel like sharpness, but if the wet color is very fluid and deep, you must work on flat to avoid runs.

Watercolor Pencils

When looking for a subject, what you choose to paint is very personal to you. This subject demonstrates how a strongly colored detail within provides a delicious foil against which other colors can work.

The vivid red door contrasts sharply against the surrounding brickwork and green foliage.

Either produce a similar sketch from a living subject, or use a photograph from your collection.

STEP 1

The first indications of the composition are softly sketched onto a smooth watercolor paper.

Using a nondominant color, such as blue, ensures that it will recede when overlaid with stronger colors. Black is much too strong at this early stage and will only muddy the colors of subsequently "wetted" pencil layers.

Once the highlight pencil colors have been blocked over the initial sketch, wet the majority of the surface with a round nylon brush, turning these colors into washes of color.

Hold pencil at the end to give you a loose, relaxed scribbly line.

<div style="writing-mode: vertical">ARTSTRIPS</div>

Gently sketch in simple shapes of picture in blue watercolor pencil.

Use edge of pencil head to softly block in main highlight colors.

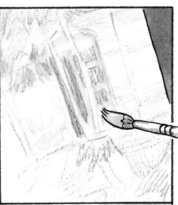
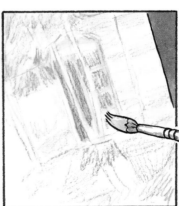

With a soft and wet brush, dissolve these strokes gently to create washes of color.

ARTSTRIPS

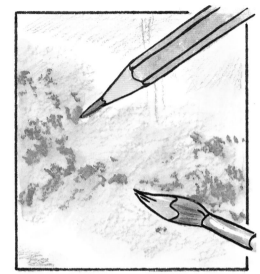

Using watercolor pencils on a surface that is still wet can be difficult to control but creates a dramatic line.

STEP 2.
Apply a second, bolder layer of pencil color, both in terms of linework and shading. By sticking to a limited palette of colors, you can learn a lot about color mixing on the surface.

Do this by overlaying colors and blending with the wet brush. Ensure that contrasts between light and shade are prominent at this stage to yield strength of tone and light with the final layer.

Accents of color are achieved by first creating a gentle pencil wash on which darker pencil marks are worked while still wet (as with leaves on bush).

Block on denser color to create contrast in value (dark against light), or in color (warm over cool).

Be more discriminating with wetted areas. Take into consideration direction of brushstroke.

Suggest structure and volume by changing direction of pencil stroke.

Use brush to gently wash any overworked areas, dabbing off color with tissue.

Line shading (hatching) now gives contrast and texture. Hold pencil toward tip for absolute control.

Overlaying line shading (cross-hatching) gives darker accents.

NOTE

Not only does texture at this stage suggest surface qualities, it is drawn in color and the color mixes visually with the colors surrounding it.

MATERIALS

Stretched Watercolor Paper

Watercolor Pencils

Round Watercolor Brush

Step 3

[A] Wall bricks gently hatched. Note how it isn't necessary to detail every brick. Work in just enough to give the feel that the pattern is repeated. Brickwork closest to the window is given the most strength.

[B] Some "L" shaped strokes of brown are applied to the bricks around the window to suggest a shadow. This makes them appear more three-dimensional.

[C] Apply more powerful layers of color to the central area to focus light, and thereby the eye, on this section.

[D] The area of path was wetted and a brush with fine crumbs of brown pencil lead scraped off with a knife directly into this wet area, dissolving into a unique texture.

[E] Black is used sparingly to add the final focus, carrying the eye through all the focal points of the composition, either as line or as hatching. Where it does become too concentrated, simply apply a blue to knock it back.

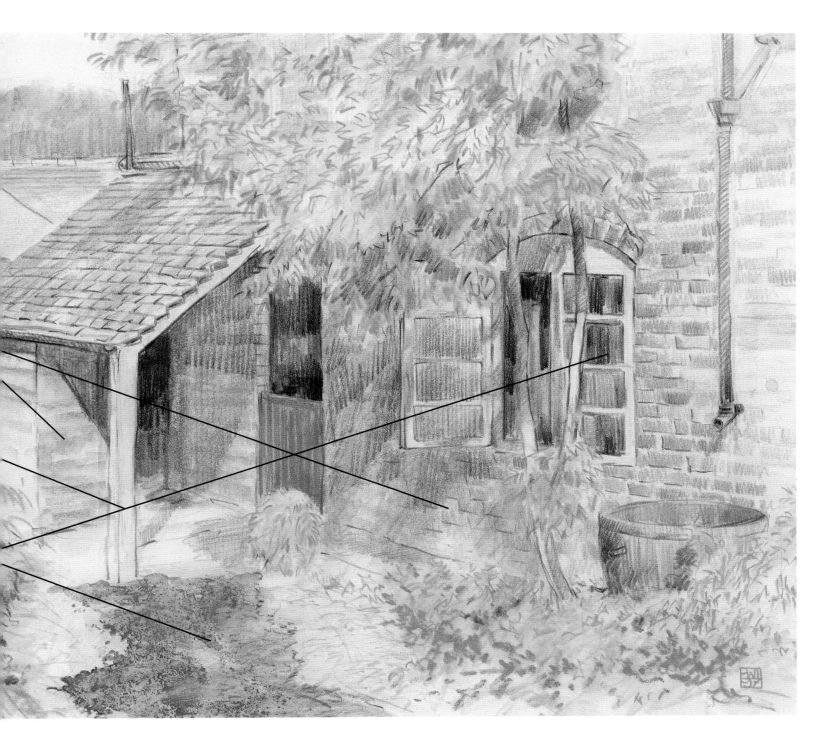

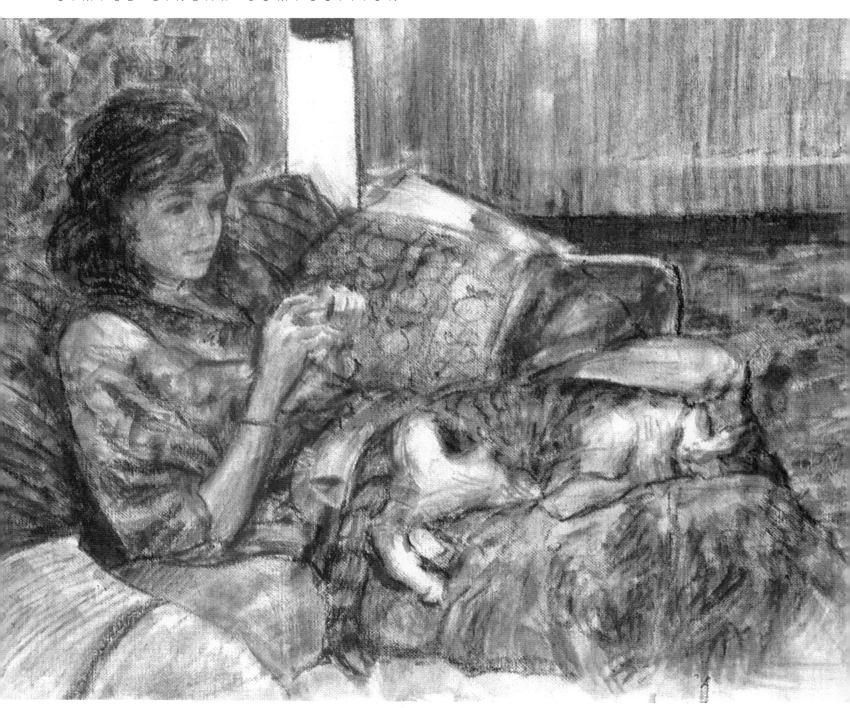

Introduction

I have to admit to being very worried when reading advice from artists on how to manage a composition. You may well have come across various do's and don'ts that may have proved very restrictive and daunting.

Let me set your mind at ease. There are no rules to composition. Creating balance in your compositions is about experience. This is why I have left this particular aspect until the last section of this book.

Let us look at one example. There is a compositional ideal known as "The Golden Rule." This is basically a mathematical formula for breaking up the rectangle of your image into a grid so that objects can be placed in the correct alignment on it surface. When explaining the works of some of the Great Masters, the initiated may tell you that a particular composition works well because it obeys the rules of the Golden Rule. They are of course right, but it does not necessarily mean that the particular artist used the grid. It is more that the balance was instinctive, an instinct acquired through the experience of observing what worked for others at the time and what was most popular.

Were you to start a composition using the Golden Rule, it is not likely to work, as following a rigorous and rigid guide such as this seldom does. Throughout the ages great artists have broken compositional rules, for it is often by breaking rules that new balances and formulas are evolved.

You may wonder why there is any point in approaching this subject. The fact is you need experience and you need to look at the design and balance used by others to assess what makes a good composition. What makes this easier for you is to possess the keys that unlock their secrets.

Once you learn to understand the underlying, hidden patterns, you will begin to use them yourself without even being aware that you are being guided.

Use the following pages to help you in the process of understanding. Try the exercises out for yourself, for in trying them the information is more likely to settle permanently in your mind.

"What's so simple about these compositions?" You would be justified in asking this. It is of course only a matter of opinion as to what constitutes a simple picture. The mere simplicity of a subject may well make it all the more difficult to capture. These exercises may not seem simple to everyone, but they are based on a simple approach. Each relies on a visual grid forming the underlying structure, which holds the composition together and controls its overall character. Being linear, each possesses rhythm, movement, and, direction. Study the idea behind them, and then look for this in the work of others. Eventually, they will have a profound effect on your own work.

MATERIALS

2mm Clutch Pencil
2B Lead

2B Graphite Pencil

Dip Pen

Reed Pen

Drawing Ink

Watercolor Paints

Acrylic Paints

Rigger Nylon Brush

Round Nylon
Watercolor Brush

Sketching Pastels

Kneadable Putty Eraser

Paper Wiper

Cartridge Paper

Range of Colored Fine
Felt Tip Pens

Hot Pressed Smooth
Watercolor Paper

Watercolor Paper

Colored Pastel Paper

Colored Cardstock

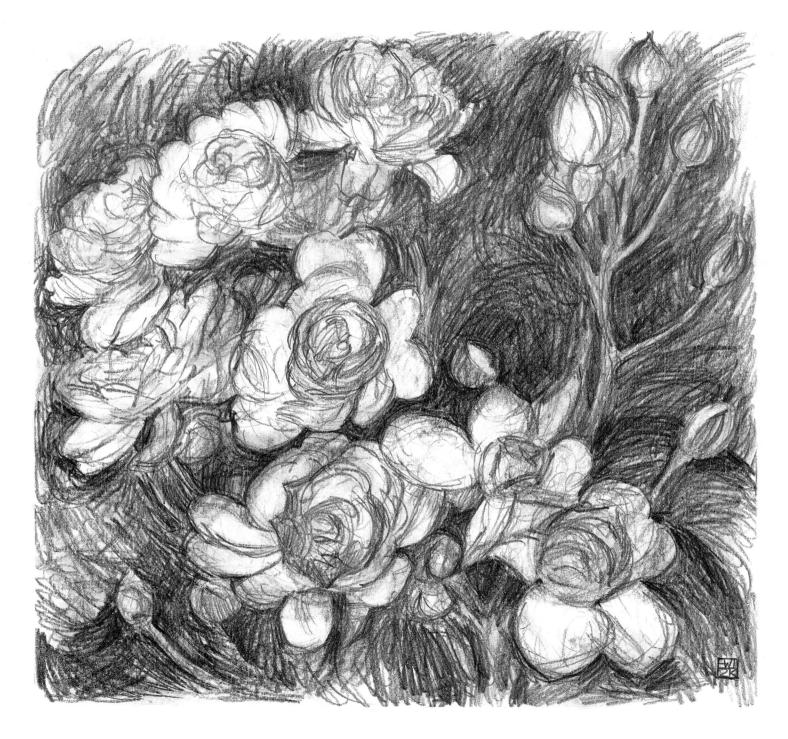

CURVES

Pencil/Cartridge Paper

Each of the studies in this section includes line that possesses particular characteristics, which delineate the composition and control its development.

Curves produce rhythms across the surface.

Ensure the linear quality is not lost as you progress through the drawing, even within the darker sections of the background.

MATERIALS

Clutch Pencil 2mm
2B

2B Graphite Stick

Kneadable Putty
Eraser

Paper Wiper

Cartridge Paper

◀ Loosely sketch in the composition with a 2mm, 2B pencil. Strengthen with the flat edge of a 2B graphite stick. Soften these with strokes of a paper wiper, but retain rhythms.

Curved hatching with the 2mm clutch pencil, followed by linework from the graphite stick, will tighten the structure. Protect the soft surface under your hand with a clean piece of paper or a tissue. Restore lost highlights using curved strokes of a kneadable putty eraser.

Finally, reinforce line or hatching with the 2mm pencil where focus or accent is required.

VISUAL GRID

These are begun as a curved grid. Not a regular structure but loose and fluid, which creates a weave of line that holds the elements together.

It is suggestive of detail, remaining soft — even though composed of line. When the drawing is complete, the subject becomes stronger than the grid, yet the latter is still present, carrying the eye across the surface.

HORIZONTAL AND VERTICAL LINE
Felt Tip

Felt tip pens can be daunting, as there is no method for erasing the line. Using a tapestry of crossing linework is one solution, with the various elements held together by the weave. Overlapping lines suggest complexity, while color can be mixed through laying colors next to, or over, one another.

VISUAL GRID

The horizontal and vertical nature of the grid provides the static, tranquil qualities that respond well to the subject. Being completed with felt tip pen, the grid reduces the influence of individual lines, which in this medium can feel a little clumsy. The eye moves up and down or across this composition.

> ### MATERIALS
> Range of Colored Fine Felt Tip Pens
> Hot Pressed Smooth Watercolor Paper

Mask the edges of the drawing with masking tape to avoid overlapping ink onto the board.

Loosely establish masses of the composition using a light neutral gray felt tip pen. Fix shadow areas with gentle cool green and light areas with pink.

Note how the foreground of the composition has a preponderance of cool colors and the background, with warm colors.

This is unusual, but gives the feel of the sun in the distant buildings. Note also the close juxtaposition of warm and cool colors, i.e. the foreground water with its purple and green hatching.

Finish with bright yellow sun highlights and touches of bright red spot color.

CONVERGING LINE
Pen & Ink

Converging lines automatically create a sense of depth. By Laying blocks of these to follow the angle of the brickwork, windows, and decoration, etc. the overall form of the buildings begins to emerge, uncluttered by detail.

While the ink is indelible, the drawing can easily be overdrawn later, if you begin with gentle solutions of ink.

Dip pens are excellent for laying regular, close linework and are used to lay the first layer of gentle hatching that loosely produces the blocks of perspective.

Once this layer is completed, wander over the structures, establishing detail and areas of interest with stronger colors. Such detail now becomes more exciting, as you can spend as much time as you want working on it.

Use a reed pen for the latter part of the drawing, being much more responsive and yielding a more descriptive, varied line.

VISUAL GRID

Buildings are often neglected as of the need for perspective. A grid of converging lines creates perspective. Details of window, brick, stonework, doors, etc. become easier because they are fixed onto an existing structure that molds them to its form.

MATERIALS
Dip Pen
Reed Pen
Drawing Ink
Hot Pressed Smooth Watercolor Paper

Begin the drawing with a rigger nylon brush and dull purple linework. Vary the thickness of line to denote light or shadow, while using fast scuffed lines to effect the texture of the wooden surface. Watercolor line allows for changes or corrections to be made easily through rewetting and lifting with a clean tissue.

Cut directional strokes across the surface with a medium round brush to model form. Move from a yellow to darker values by progressively adding the line color, which needs prior mixing.

LINEAR PLANES
Watercolor
The Cubists were first inspired by the structure of African masks.

Here an Indian relief carving allows us to explore the possibilities offered in identifying structure as a series of flat planes.

Line hatching can suggest the direction of a carved surface, or the grain of the wood.

VISUAL GRID
Breaking the subject down into flat surfaces is not unlike carving space with line. Using it to depict a carving from wood is only the beginning. All objects can be approached in this manner. Set up a still life and analyze and simplify the structure of the objects into directional planes. It isn't as difficult as it sounds. It is only a matter of tuning your eye into this new way of looking at things.

MATERIALS
Watercolor Paints
Rigger Nylon Brush
Round Nylon Watercolor Brush
Watercolor Paper

PARALLEL STROKES

Mixed Media

While the finished drawing appears to be pure pastel, the underlying linework is completed in watercolor, using the point of a medium round brush to provide the accuracy and the dark values which pastel cannot. The pastel softens the watercolor and adds its own unique intensity of color.

Apply initial paint colors as dark colored-grays, laid either vertically, horizontally, or diagonally to suggest the rain. Carry vertical elements of the building straight down into the wet surface as reflections. This dark structure establishes directional movement across the picture, but is actually devoid of much sharp detail and thus more atmospheric.

Pastel strokes overlay the watercolor and are blended at first with a paper wiper in the direction of the underlying watercolor line, thus softening the overall effect. Later, as the colors are lightened, they are laid more solidly again, following the dictates of the directional structure beneath.

VISUAL GRID

Parallel lines can be very powerful in pulling the eye along with them. With this parallel line grid, the vertical parallels yield the strong structure of the parallel buildings. In the wet surface the lines are horizontal, arranged in vertical columns. This exercise provides an insight into the creation of reflection surfaces found in water, glass, or metal. Diagonal parallel lines effectively suggest the downpour of rain. Decide whether pastel strokes should follow the vertical, horizontal, or diagonal line.

MATERIALS
Watercolor Paints
Round Watercolor Brush
Sketching Pastels
Colored Pastel Paper

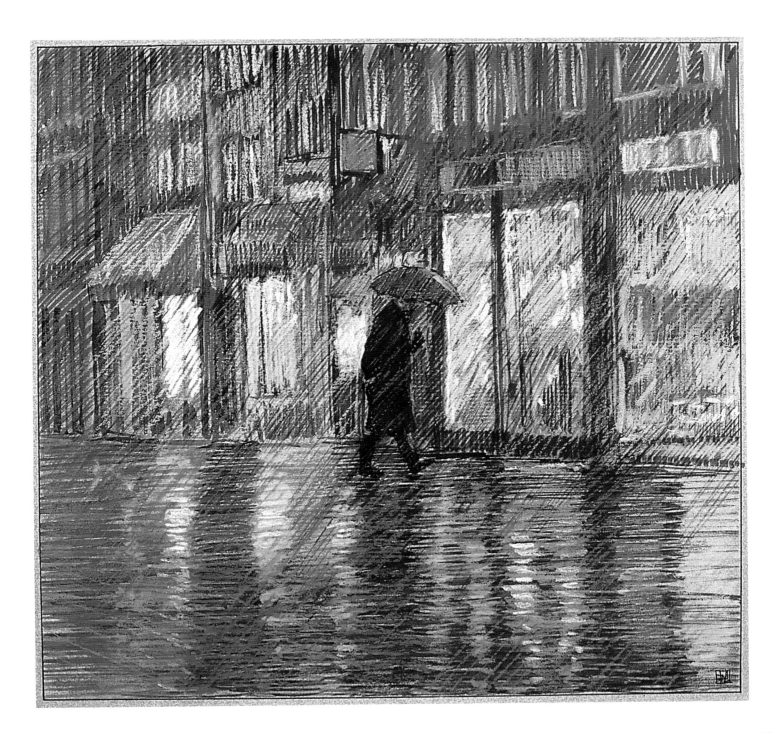

RANDOM FLOW
Acrylics

The ultimate linear stroke is created by squeezing paint directly from the tube onto the painting surface. The mosaic of strokes builds directional flow across the surface, which captures the eye and carries it along.

Work upright so that the angle of paint application from the tube is easier — and you are likely to catch the surface with your hand. Using acrylic ensures the paint dries swiftly and adheres strongly to the surface. Thick cardstock, such as the back of an old sketchbook, is perfect for this exercise, as it provides a rigid support and a dull-colored surface against which the colors can shine. You will need more colors here, including premixed secondary colors, along with black and white.

While color is not mixed on the surface, there is some exciting streaking as the colors meet on the surface. Start with a guiding pencil outline. Vary pressure and the angle of application with the tubes. Bear in mind that small tubes have smaller nozzles that yield better detail.

VISUAL GRID

The visual grid was beloved of the Impressionists and Post Impressionists. It is random flow of strokes to create pattern and structure, which excites the eye with its mosaic colors.

MATERIALS
Acrylic Paints
Colored Cardstock

ART TECHNIQUES FROM PENCIL TO PAINT
by *Paul Taggart*

Based on techniques, this series of books takes readers through the natural
progression from drawing to painting and shows the common
effects that can be achieved by each of the principal media, using a variety of techniques.

Each book features six main sections comprising of exercises and tutorials
worked in the principle media. Supportive sections on materials and tips,
plus color mixing, complete these workshop-style books.

Book 1
LINE TO STROKE

Book 2
LINE & WASH

Book 3
TEXTURES & EFFECTS

Book 4
LIGHT & SHADE

Book 5
SKETCH & COLOR

Book 6
BRUSH & COLOR

ACKNOWLEDGMENTS

There are key people in my life whom have inspired me over many, many years,
and to them I extend my undiminishing heartfelt thanks.
Others have more recently entered the realms of those in whom I place my trust and I am privileged to know them.
Staunch collectors of my work have never wavered in their support,
which has enabled me to continue to produce a body of collectable work,
along with the tutorial material that is needed for books such as this series.
I will never cease to tutor, for the joy of sharing my passion for painting is irreplaceable
and nothing gives me greater pleasure than to know that others are also benefiting from the experience.

INFORMATION

Art Workshop With Paul Taggart is the banner under which Paul Taggart offers a variety of learning aids,
projects and events. In addition to books, videos and home-study packs, these include painting courses,
painting days out, painting house parties and painting holidays.

ART WORKSHOP WITH PAUL

Log on to the artworkshopwithpaul.com website for on-site tutorials
and a host of other information relating to working with
watercolors, oils, acrylics, pastels, drawing and other media.
http://www.artworkshopwithpaul.com

To receive further and future information write to:-
Art Workshop With Paul Taggart / PTP
Promark
Studio 282, 24 Station Square
Inverness, Scotland
IV1 1LD

E-Mail : mail@artworkshopwithpaul.com

ART WORKSHOP WITH PAUL TAGGART
Tuition & Guidance for the Artist in Everyone